# THE ILLUSTRATED HISTORY OF THE

# SNOWMAN

## BOB ECKSTEIN

*New York Times* Best-selling Author and Snowman Expert

## Globe Pequot

Guilford, Connecticut

In drifting flakes he came aboard
And on the deck he laid him down
We gave him shape, a swab for sword
The skipper's Sunday hat for crown
But when the purser asked his fare
And only got an icy look
For satisfaction, then and there
We brought our passenger to book.
                    —*Our Christmas Passenger*,
                        written and drawn by Cyrus Cuneo

**FACING PAGE:** *Originally appeared in the* Illustrated London News, *1902.*

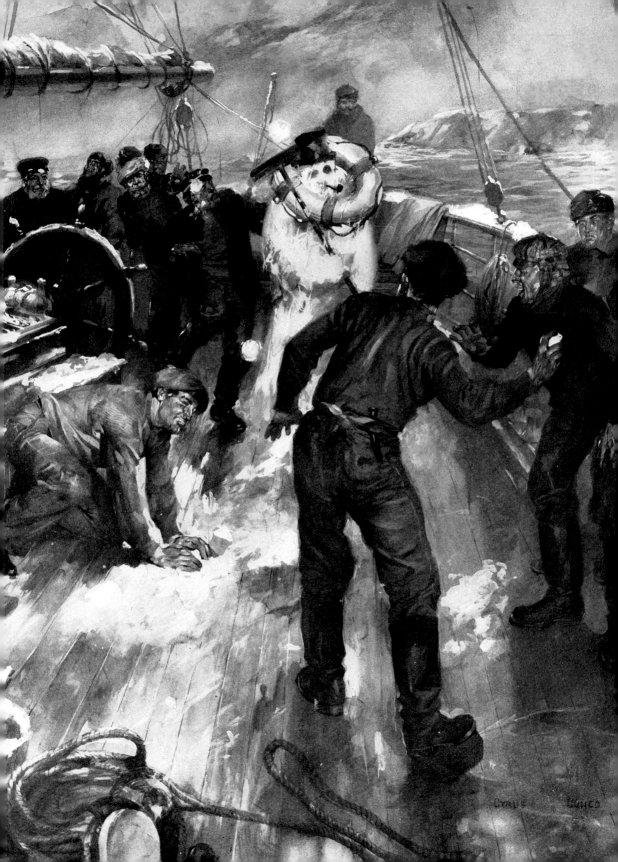

## Globe Pequot

An imprint of The Rowman & Littlefield Publishing Group, Inc.
4501 Forbes Blvd., Ste. 200
Lanham, MD 20706
www.rowman.com

Distributed by NATIONAL BOOK NETWORK

British Library Cataloguing in Publication Information available

**Library of Congress Cataloging-in-Publication Data available**

ISBN 978-1-4930-3666-0 (hardback)
ISBN 978-1-4930-3667-7 (e-book)

∞™ The paper used in this publication meets the minimum requirements of American National Standard for Information Sciences—Permanence of Paper for Printed Library Materials, ANSI/NISO Z39.48-1992

Printed in the United States of America

# CONTENTS

*"Jumping Snowman,"* letterpress
printing. COURTESY OF SATURN PRESS

# INTRODUCTION

**W**ho made the first snowman? Who first came up with the idea of placing one snowball atop another and then sticking a carrot in the top sphere? What evidence could be left? Random pieces of coal once the buttons to an ancient snowman's coat?

That was my personal quest, my own Holy Grail, starting almost twenty years ago, speaking to art and religious historians, professors of medieval customs, heads of Asian studies, and gentlemen scholars. I combed turn-of-the-century publications, historic journals, and libraries around the world.

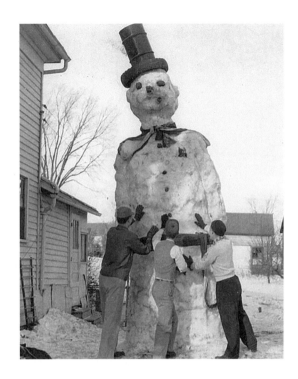

*Kiel, Wisconsin, ca. 1950.* PHOTO COURTESY OF UNIVERSITY OF WISCONSIN DIGITAL COLLECTIONS

❝ We share very few of our hundreds of day-to-day activities in common with our ancestors. But snow sculpture may be one of them. ❞

Although it may appear the snowman neither changed history nor afforded us any obvious lesson, time and time again this frozen Forrest Gump has been part of key historical moments, appearing alongside dignitaries and celebrities in snapshots of our world's history. This book is as much about the snowman as it is a fingerprint of our pop culture. And who's to say what is important in history. Lexicographer Dr. Samuel Johnson said, "All knowledge is of itself of some value. There is nothing so minute or inconsiderable that I would rather know it than not. A man would not submit to learn to hem a ruffle . . . but if a mere wish could attain it, he would rather wish to be able to hem a ruffle."

"Much of history is hemming ruffles," said historian Dixon Wector in response. As for me, I have dwelt at length on the history of the snowman because it is time to give him his due—time to hem his ruffles. I may not know why historians would use sewing

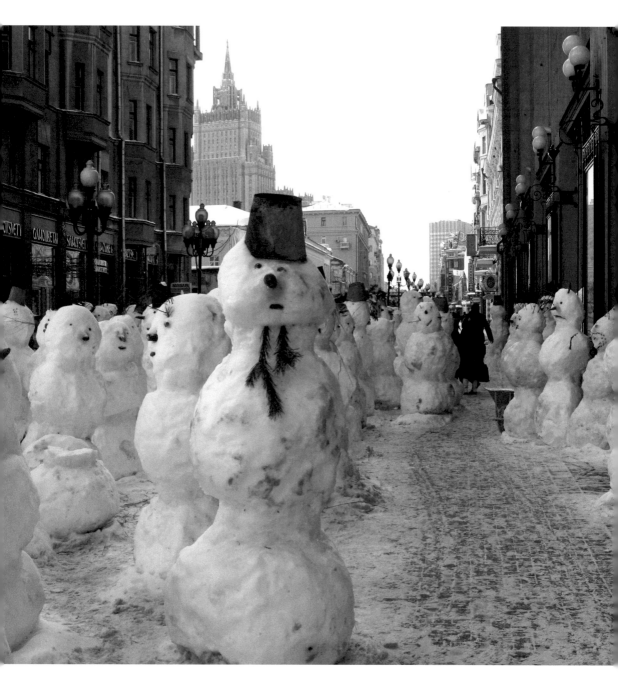

*Street in Moscow.* PHOTO BY NIHOLAS DANILOV, MOSNEWS.COM, 2005

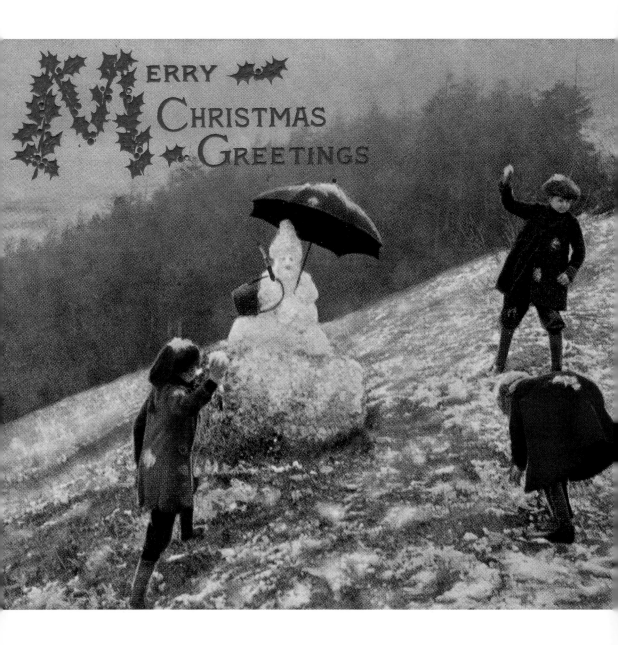

MERRY CHRISTMAS GREETINGS

Oilette

as a metaphor, but one thing I'm sure of is that the snowman's history is as colorful and as vast as many other items to which we pay credence.

The snowman's story will establish his place in history. History is indeed an elastic, inviting concept, which encompasses the most remote records left on earth to the next dusting of snowflakes. Pioneer historian Leopold von Ranke, in 1860 called history both "a science and an art."

We share very few of our hundreds of day-to-day activities in common with our ancestors. But snow sculpture may be one of them. As Plato said, humans have a common and simple need to imitate what they see, to create art, and to depict themselves. With a well-placed twig or piece of coal, one can give a pile of snow an expression and bring it to life. Making a snowman is the first and probably the last time one will create a life-size human figure. Whether it's a primal instinct or a learned skill, snowman making is always precipitated by joy—like Pavlov's dogs, kids run to the window as soon as snow starts falling. When the free art supplies start to blanket yards, it's not long before snow people begin appearing, often under the most joyous circumstances—that school is cancelled.

Picasso has never appeared in a breakfast commercial, but the snowman has. Muhammad Ali and Jack Nicklaus combined haven't graced as many magazine covers as the snowman. Who's had his face on more postage stamps? You'd be hard-pressed to find a celebrity who crosses international boundaries as universally as the snowman. No one is more beloved, more popular than the snowman. No one has appeared

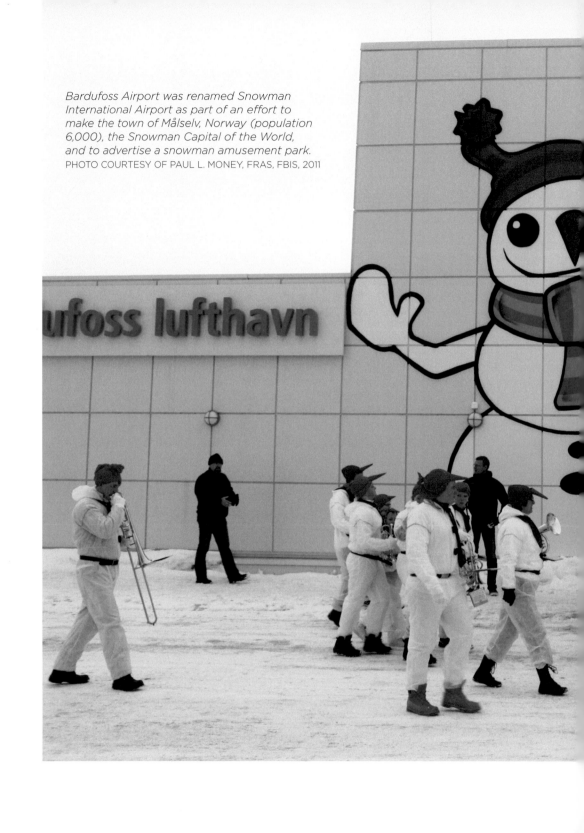

*Bardufoss Airport was renamed Snowman International Airport as part of an effort to make the town of Målselv, Norway (population 6,000), the Snowman Capital of the World, and to advertise a snowman amusement park.*
PHOTO COURTESY OF PAUL L. MONEY, FRAS, FBIS, 2011

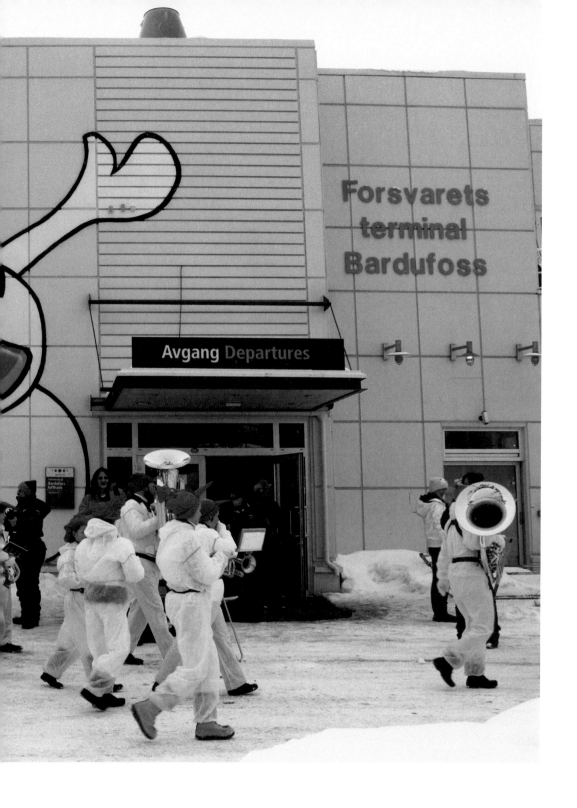

*German kids carving a snowman.*

in more movies, been mentioned more often in literature, or landed more endorsements hocking everything from Cadillacs to laundry detergent to tuna casserole. Arguably— with the exception of religious figures—the snowman is the single most recognized icon in the world.

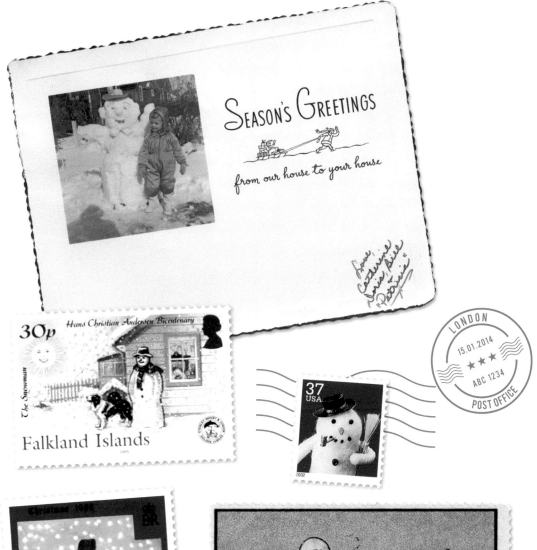

SEASON'S GREETINGS

from our house to your house

Love,
Catherine
Chris, Bill
& Patricia

30p

Hans Christian Andersen Bicentenary

The Snowman

Falkland Islands

37
USA

2002

LONDON
15.01.2014
★★
ABC 1234
POST OFFICE

Christmas 1988

EIIR

Gibraltar

4a

Questa

R.Falero age 8

Der Schneemann ist recht fein geworden.
Jetzt hat er auch noch einen Orden.

# SNOWMAN'S INDEX

Average number of
**CALORIES BURNED,**
per hour, building a snowman

## 238

## 24
Number of movies
with **SNOWMAN**
in the title

## 6
Number of those in
which the snowman
is the **KILLER**

Length, in minutes,
of the 1896 **SILENT
MOVIE** *Snow Men*

## 3

## 4
Number of silent
movies made
about snowmen

## 1

Years it appeared after
the invention of the
first silent movie

12

18

14

20

18

16

18

## 12,379
Number of snowmen made in Sapporo, Japan
**(WORLD RECORD)**

Average number of **SNOWFLAKES** it takes to make a snowman

# 10,000,000

## 4

Number of companies selling "only **SNOW** required" snowman building "kits"

## 122

Height, in feet, of **OLYMPIA,** the world's largest snowman (actually a woman)

## 13 MILLION

Amount of snow, in **POUNDS,** it took to make Olympia

The size of her spruce tree arms, in feet

## 30

## 130

The length of her scarf, in feet

## 1

Time, in months, it took to complete Olympia

## 2,000

Number of snowmen made in Shiramine Village, Japan, during **SNOWMAN WEEK,** 1993

## 1,200

Number of people who were living in Shiramine Village

# 8,000,000

Number of historical pieces of art on record at The Hague's Royal Library

# 2

Number of snowmen found within that collection

# 15,000

Number of those defined as **"WINTERSCAPES"**

Number of snowmen in Karen Schmidt's (Minnesota, USA) collection

# 2,036

# 37,000

Approximately, the number of "snowman" items for sale on **EBAY** on any given day

# $315

Winning bid for a 3-inch German cotton snowman **ORNAMENT** on eBay

**0.0004**

Height, in inches, of the world's **SMALLEST** snowman (made in a laboratory)

Number of snowmen made in **ONE HOUR** in Hokkaido, Japan (world record)

# 2,036

# OVER
# 90,000

Number of **YOUTUBE VIDEOS** to teach you how to make a snowman

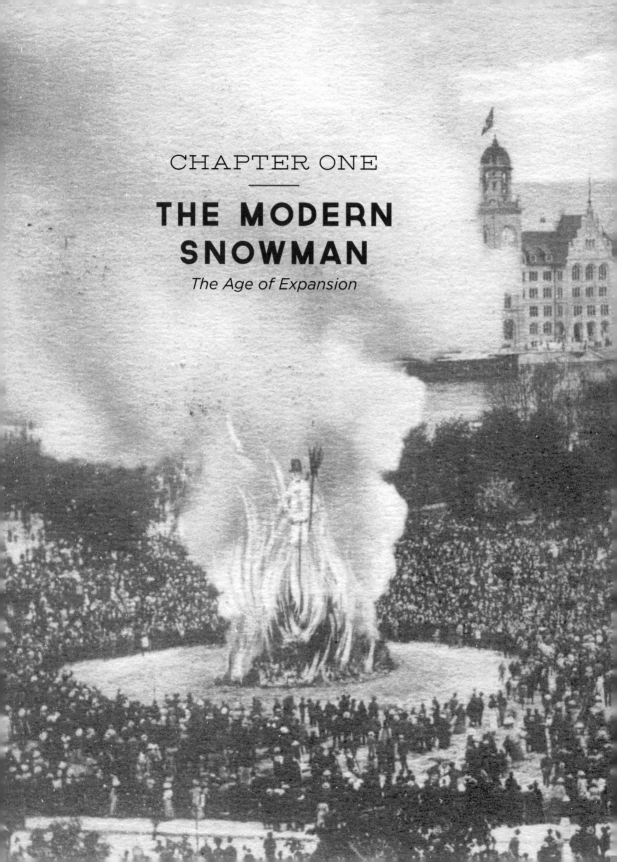

# CHAPTER ONE

—

# THE MODERN SNOWMAN

*The Age of Expansion*

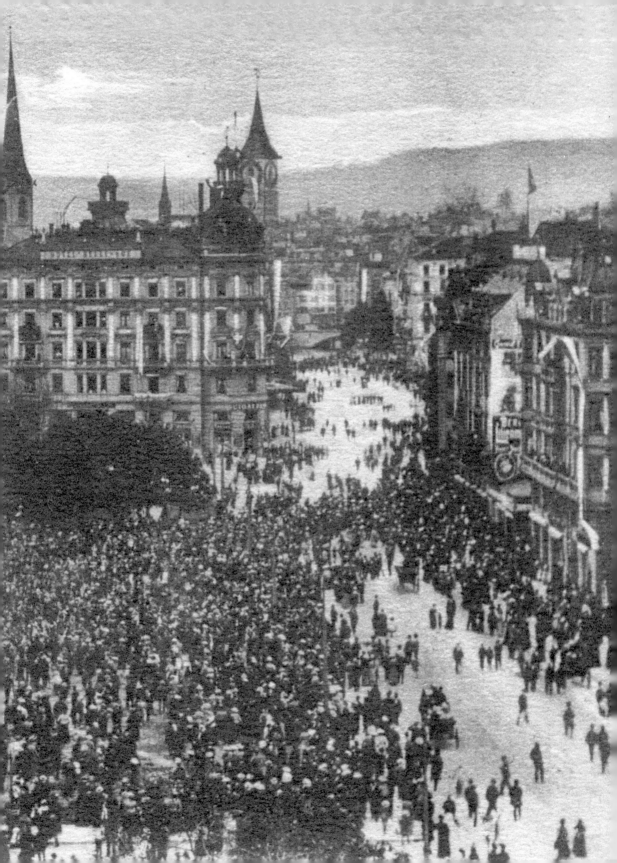

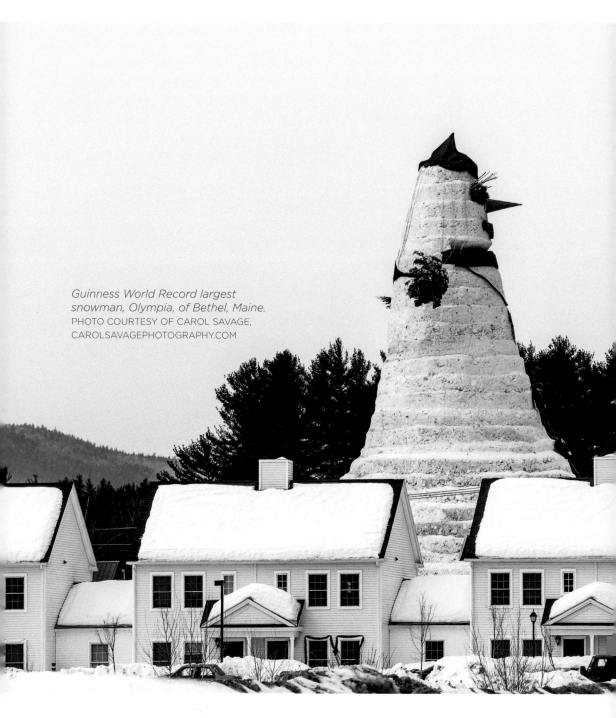

Guinness World Record largest snowman, Olympia, of Bethel, Maine.
PHOTO COURTESY OF CAROL SAVAGE,
CAROLSAVAGEPHOTOGRAPHY.COM

**PREVIOUS SPREAD:** *Zürich, Switzerland, celebrating Sechseläuten. 1905.*

Hundreds of snowman festivals and contests take place around the world every year and this continues to grow. The biggest is the Ice Lantern Festival (Ice and Snow World) in Harbin, China. Each year millions travel to the "Ice City" where the temperature stays below freezing nearly half the year. Held from the beginning of January to the end of February, the festival exhibits thousands of enormous sculptures and buildings, some of which are paraded on floats through the city. Although these snow shows date back to 1963, snow sculpture there dates back to the Qing dynasty about 350 years ago.

During the Manchu days, "ice lanterns" were carved and then lit by placing candles in them. A similar tradition is also enjoyed today throughout Japan, where snowmen have candles placed in their stomachs during the many snowman festivals, which take place every winter.

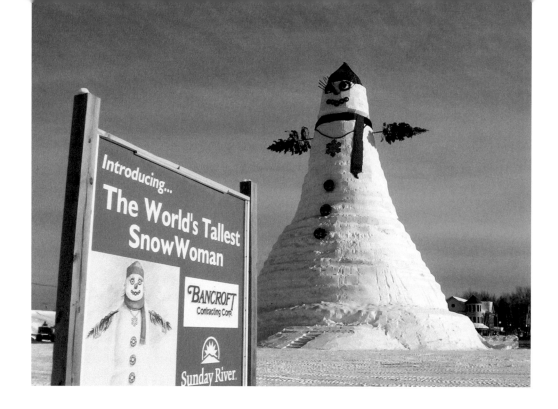

Extreme snowman-making has come a long way since the day a bunch of frat boys from Dartmouth made the thirty-eight-foot-high *Eleazer Wheelock*, the headline act for the 1939 Winter Carnival. Today, making a huge snowman involves cranes, teamsters, and insurance. Don't even think about making a snowball the size of an igloo without a working permit. Certainly not if you plan to break any records, like the town of Bethel in Maine does on a regular basis. They twice built the world's tallest snowman, beating their own record in 2008 by 10 feet. Named after Sen. Olympia Snowe (Maine from 1995 to 2013), "Olympia" is actually a snow-woman with 16 skis for eyelashes and bright red tires for lips. Her eyes were made with wreaths, and she had 30-foot evergreens for arms and an 8-foot carrot nose made by elementary schoolchildren. Almost as tall as the Statue of Liberty (minus the base), she stands 122 feet tall. Man-made snow was used in the beginning, and later a 150-foot crane dumped snow from the runways of Bethel Regional Airport into frames to hold her shape,

**OPPOSITE:** *The world record snowperson, Olympia. Bethel, Maine.* PHOTO COURTESY OF BETHEL AREA CHAMBER OF COMMERCE, BETHELMAINE.COM/SNOW-PEOPLE

**RIGHT:** *World's largest snowman house. Beardmore, Ontario.* PHOTO BY R. ETTINGER

**BELOW:** *World's largest snowman made out of stucco. North St. Paul, Minnesota.*

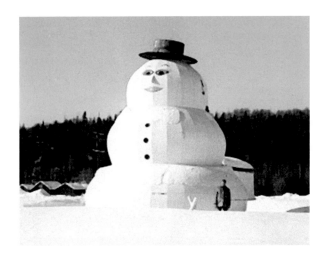

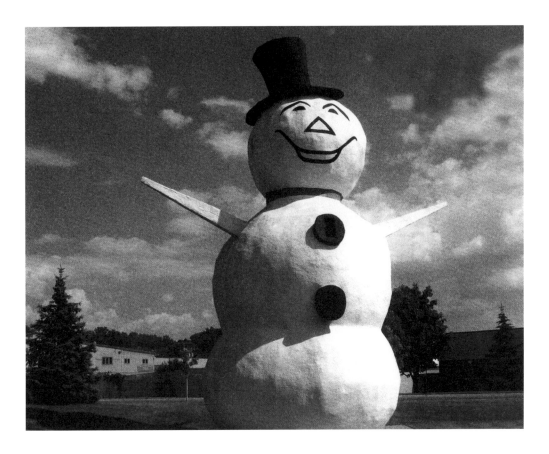

like a girdle. Instead of the usual three-balls-stacked technique, Olympia was built in concentric circles with volunteers shoveling and packing the snow. Only the bravest continued—one volunteer stated, "It got hairy up at the top. I only made it to 80 feet." It took most of the town of Bethel one month to complete the record sculpture. It took another five months for Olympia to slowly melt away.

Not every large snowman dies a quiet, slow death. Each year in Zurich, the Swiss celebrate *Sechseläuten* by using large amounts of explosives to blow up an innocent snowman. On the

*The snowman is the toast of the town, literally.* COURTESY OF WIKIPEDIA

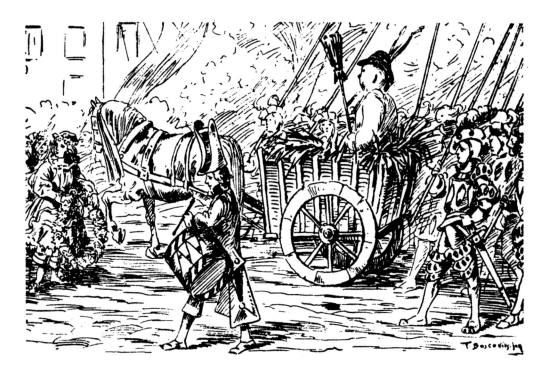

*A snowman stuffed with dynamite is paraded through the streets of Zürich for the explosive festival of Sechseläuten.* FROM SECHSELÄUTEN FEST DES FRÜHLINGS, DER ZÜNFTE UND DER JUGEND. 1897 DRAWING COURTESY OF ORELL FÜSSLI VERLAG PUBLISHING

*January 18 is World Day of Snowman.*

> **"** When the head of the snowman explodes to smithereens, winter is considered officially over. **"**

third Monday in April, bakers, butchers, blacksmiths, and other tradesmen parade on horses, throwing bread and sausages to the crowds. Girls decorate the riders with garlands made of spring flowers. The parade includes over 3,500 marchers, 350 horses, 50 floats, and over 30 marching bands.

Sechseläuten (Swiss German for "six bells ringing") comes from the medieval tradition that at six o'clock, the guild members put down their tools and called it a day. Meanwhile, the *Böögg* is schlepped through town. The Böögg is a large cotton-wool snowman with a corncob pipe, button nose, and two eyes made out of coal—he looks the same every year because the same guy has been making the Böögg for over thirty-five years. Unfortunately for Mr. Böögg, he's filled with firecrackers and plopped on a forty-foot pile of very flammable scrap wood. After the bells of the Church of St. Peter have chimed six times, representing the passing winter, the townspeople light the pile and watch the carnage. This is followed by Switzerland's largest impromptu barbecue, as everyone uses the fire to grill the sausages they've brought or collected from the parade.

The first festival was in 1867, and the tradition of the blowing up of the Böögg started in 1902. It is believed that the shorter the combustion is, the hotter and longer the summer will be. When the head of the snowman explodes to smithereens, winter is considered officially over. In 2006 the Böögg was abducted by leftist revolutionaries, as Sechseläuten is considered an upper-class holiday and is within days of May Day, a working-class holiday.

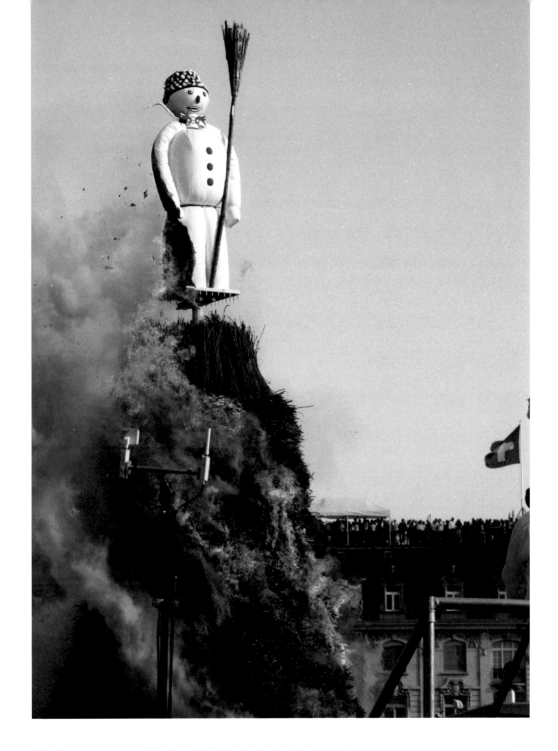

*Blowing up snowmen is a legal holiday in Switzerland.* PHOTO COURTESY OF TREVOR WILSON

> " The snowman, now the poster boy for climate change. "

Since then, the Böögg is safely protected in a bank until the day it's destroyed.

The one other holiday that focuses on the snowman is World Day of Snowman. It was originated by German snowman collector Cornelius Graetz on January 18, 2009. The 18th was chosen to distance the day from any major holiday, and because the one and eight together resemble a snowman holding a broom. Based on the similar verbiage and talking points found on the official World Day of Snowman website, it appears the holiday was inspired by the first edition of this book, my 2007 *The History of the Snowman*. This could become an important holiday to focus on global warming and raise awareness of climate change. The celebration can include going out to make a snowman on the 18th, because we do not know how many more years we will be able to continue making snowmen. The snowman can make its mark in history, becoming a vital poster boy and spokesperson for global warming.

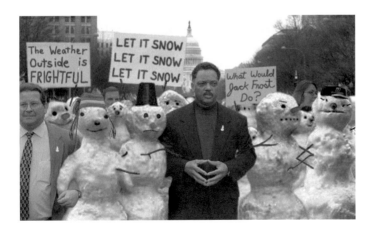

*Nation's Snowmen March Against Global Warming.*

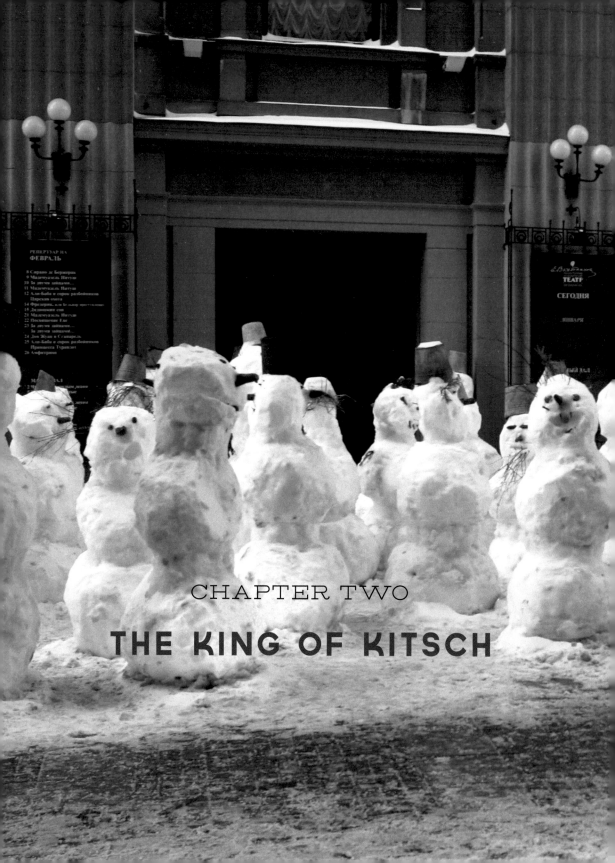

CHAPTER TWO

# THE KING OF KITSCH

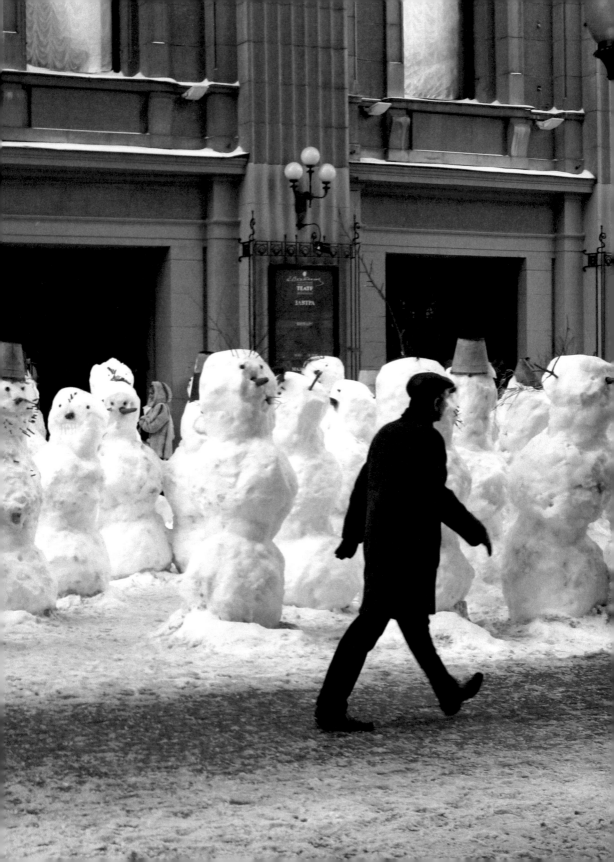

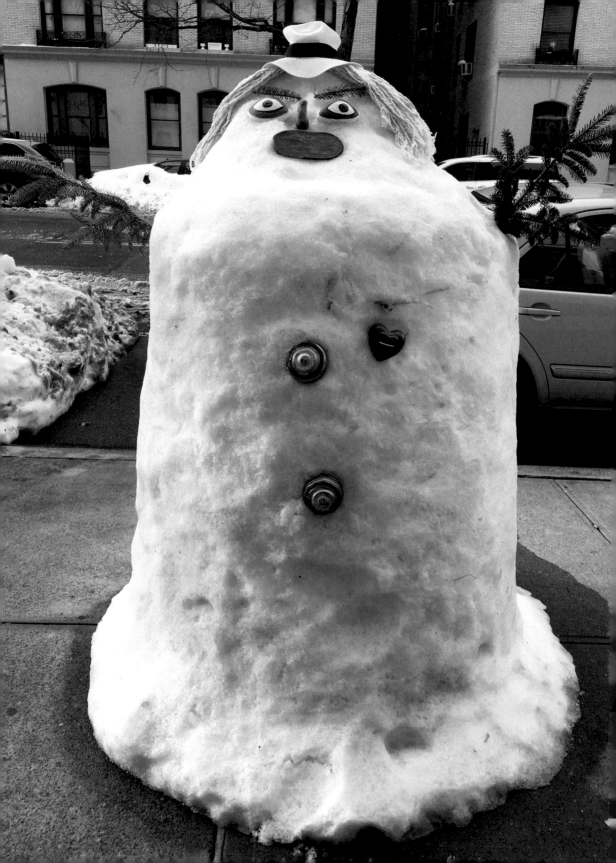

**B**etween the Age of Expansion and Frosty was a curious period from about 1975 to 2000, when the snowman was the king of kitsch. Starring in B-movies and indulging in other shenanigans, there were a lot of poor choices being made, mostly in the form of holiday home décor.

But the snowman's fall from grace is part of the predictable and logical celebrity arc, which becomes all the more clear as the snowman's past is traced: 1) humble beginnings from the backwoods (or backyard), 2) the big break with unforeseen fame and fortune, 3) reckless excess, 4) collapse, and finally, 5) a larger-than-life triumphant comeback, often in the form of an appearance in a presidential library or comedy sitcom.

At some point in Tinseltown, there was a meeting where a movie producer actually suggested that what the public really had a hankering for was a deranged knife-wielding snowman with a penchant for revenge. Like the transformation of Batman from the campy TV series to Tim Burton's *Batman*, the dark brooding crusader, the snowman went from Frosty to frightening.

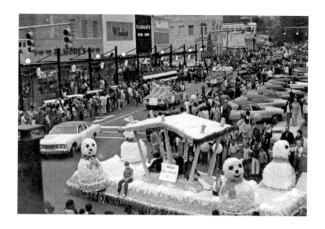

*The Ozark, Alabama, Christmas parade.*

*At this time, snowmen began looking more and more like cakes, similar to the popular Betty Crocker frosted layer cakes of the late 1970s.*

So began the snowman's new ill-advised direction in movies. Decapitation by sled, icicle bullets, and strangulation by use of tangled Christmas lights? Not exactly the warm memories of a Yuletide of yore, but exactly what unprepared holiday frivollers got when they went to see *Jack Frost* (1997). Its sequel (for some reason) *Jack Frost 2: Revenge of the Mutant Killer Snowman* was released in 2000 with taglines like *"He's Chillin' 'n Killin'"* and *"He's Icin' and Slicin'"* to an equally cold reception. Even in Germany, *Jack Frost* was showcased in 2015 as one of the worst films ever. Yet despite Feliz NaviDEAD box office sales, Hollywood keeps trying to push the snowman in the slasher genre, convinced the snowman is very scary. Some would argue that is the case. A segment on British television in 2011 about "festive phobias" included a hysterical housewife with a petrified fear of snowmen (experts tried to help her overcome her fear by having someone dressed in a

snowman costume approach her in a friendly manner). Certainly, *The Snowman* scared away moviegoers. The 2017 star-studded grisly horror flick, based on the Jo Nesbø bestseller, earned some of the worst reviews in recent memory. Yet, as of this printing, there are at least a couple more snowman movies in development.

On the print media side of things, when Archie-style comic books took a backseat to superheroes, story lines emerged depicting evil snowmen taking on the likes of Batman, Wonder Woman, and Superman. One of the many villainous snowmen included "Klaus Kristin," a.k.a. "Snowman," a.k.a. "The Snowman of Gotham," who first appeared in Batman comics in 1981. An ice-powered criminal, he has a story like so many others. Born the son of a yeti (one of those Abominable Snowmen), he prefers existing in cold climates and traveling eight months of the year to follow blizzards, making it difficult for him to hold down

*The snowman made popular again by rappers.*
© PICTURETOWN, INC., 2007

a steady job. Broke, he abuses his superpower—the ability to cause anybody to freeze solid—and begins robbing people. That pretty much sums up all the bad snowmen depicted in comics.

As video games emerged, as one would imagine, of course there were violent snowmen. Fruits and vegetables are violent in video games. Nevertheless, menacing snowmen involving bounty hunters and icy snowballs are commonplace.

Meanwhile eBay was creating a more visible, far-reaching monster—the snowman as the King of Kitsch. At any given moment on eBay, there are thousands of snowman items available for fervent collectors. Fierce and unparalleled, reckless bidding can erupt anytime over a knitted snowman kitchen appliance cozy or rug-hooked toilet seat cover. So how did our frosty friend reach such lofty heights as the King of Kitsch?

Before the snowman motif was used for every craft

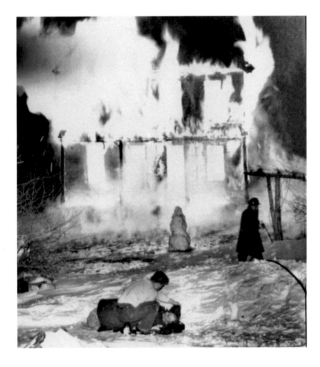

*Newspaper story of a Pennsylvania family being saved from a burning home and their snowman fighting the heat.*
LEBANON DAILY NEWS, UNITED PRESS TELEPHOTO, 1958

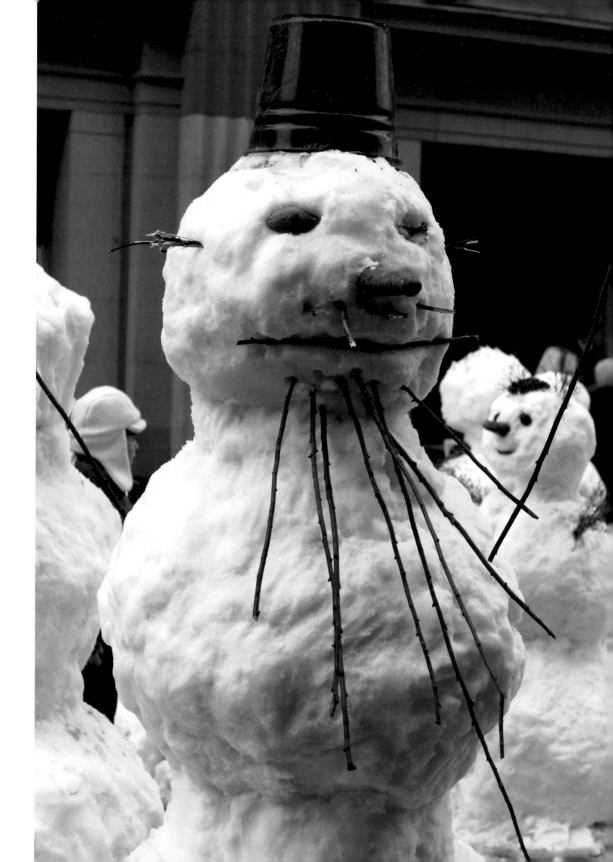

*Not a rare glimpse of the snowman black market but professional snowman-makers hired by The Russian Theatre as publicity for their winter season.*
NIHOLAS DANILOV, MOSNEWS.COM

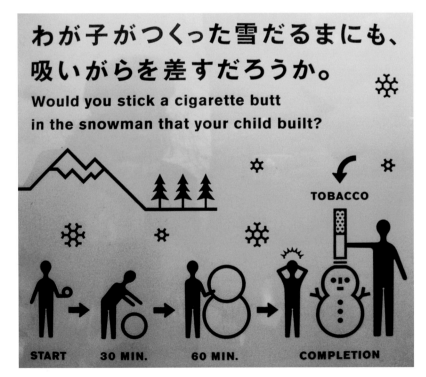

わが子がつくった雪だるまにも、
吸いがらを差すだろうか。

**Would you stick a cigarette butt in the snowman that your child built?**

TOBACCO

START    30 MIN.    60 MIN.    COMPLETION

*A snowman public announcement in Japan.*

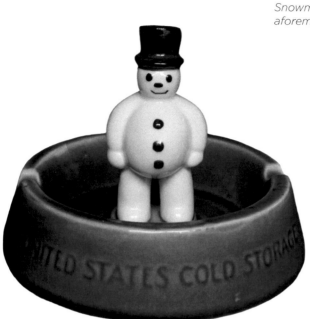

*Snowman ashtray for those aforementioned cigarette butts.*

you can imagine, he *was* the essence of folk art. A chance at self-expression, a creature of whim and climatic circumstance— whenever winter dropped snowfall outside everyone's front door, it was an opportunity for the artist in all of us to come out. For some it may be the only time of the year they allow themselves to create art, art that couldn't be more publicly judged. The snowman is now as American as baseball or apple pie.

  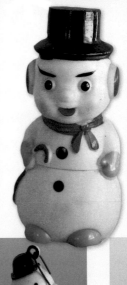 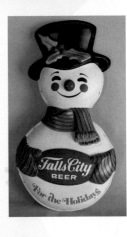

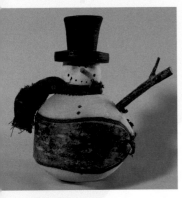   

 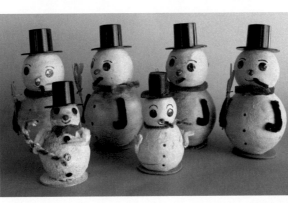 

A portion of the author's snowman collection made up of rubber dog toys, soap, snow globes, clay and brass sculptures, singing statuettes, plastic wind-up toys, Lego creations, cotton Christmas ornaments, sewing thimbles, bottle openers, and ashtrays.
TAMAR STONE, 2018

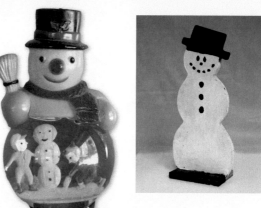

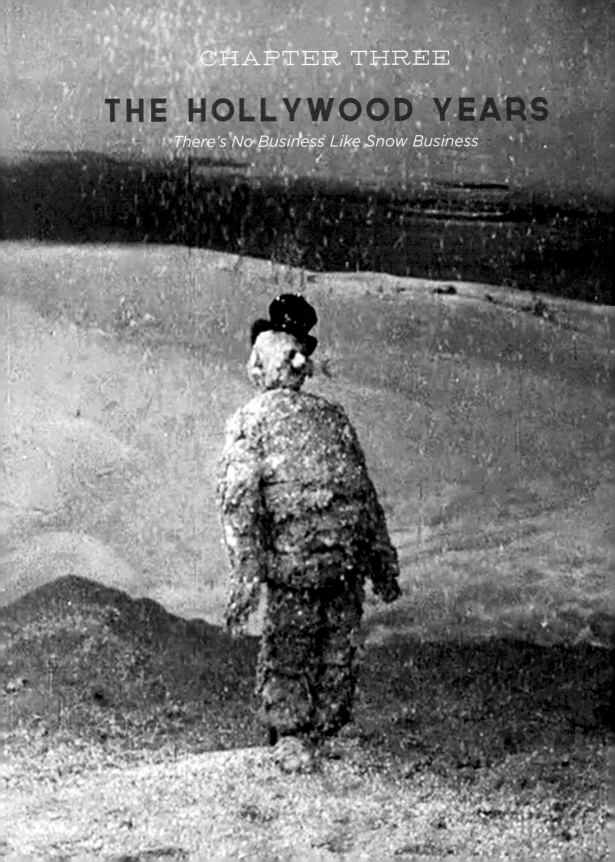

# CHAPTER THREE

# THE HOLLYWOOD YEARS

*There's No Business Like Snow Business*

*One of the earliest movie stills including a snowman, from* The Snowman *(1908), directed by Wallace McCutcheon, starring Bobby Harron. Photographed by G. W. Bitzer.* COURTESY OF THE MUSEUM OF MODERN ART

*Psycho killer snowman from the movie* Jack Frost, *1997.*

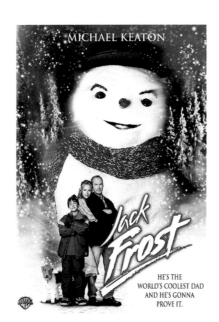

Jack Frost *starring Michael Keaton.*

*Sheet music from the play* Snowmen on Parade.

The snowman's best-known role is as Frosty the Snowman, a role that forever changed the world's perception of the snowman. But the snowman has appeared in hundreds of flicks, from the birth of the silent movies to holiday blockbusters like *Holiday Inn* and Raymond Briggs's animated Oscar-nominated *The Snowman*.

In *Jack Frost* (1999), Michael Keaton is reincarnated as a snowman when his son plays his dead father's magic harmonica and he comes back to life in the front yard. The widowed mom learns of this development herself in a more disturbing way; she gets a phone call from the snowman (raising both plot and logistical questions). The movie's most poignant exchange includes the following lines:

Jack Frost (dad): "You da man!"

Charlie: "No, YOU da man!"

Jack Frost: "No, I da *snowman*!"

Film critic Roger Ebert said in his book *I Hated, Hated, Hated This Movie*, "Never have I disliked a movie character more."

> **"** The snowman's first scene (a pivotal one) in a major motion picture was in *Citizen Kane* (1941), regarded as one of the greatest films ever. **"**

Two years earlier *Santa vs. the Snowman* came out. It's a 3-D film in which a snowman tries to steal Christmas using igloos mounted on stilts, à la *Star Wars*' Imperial walkers.

Today, the snowman occasionally makes a film cameo (*Elf*, *Groundhog Day*, *Gremlins*, *Polar Express*), but the snowman's first scene (a pivotal one) in a major motion picture was in *Citizen Kane* (1941), regarded as one of the greatest films ever. While Kane is constructing a snowman, his mom is inside changing his fate, signing him away. The scene ends with talk about the snowman and [SPOILER ALERT] Kane using his sled Rosebud to push away his new parental guardians. Some say this is the greatest scene Orson Welles ever filmed. Welles admitted Kane's character was as much based on himself as Hearst. The rotund director grew up in wintry Wisconsin where he, probably, made snowmen—Welles had an obsession with childhood and was nostalgic about snow, using it as a device to convey innocence, like the snowballs of *Les Enfants Terribles* (1950) and the kiss in the snow in *The Magnificent Ambersons* (1942). [SPOILER ALERT] At the end of *Citizen Kane* a glass paperweight falls from Kane's hand at the moment he dies, and a close-up shows a snow-covered house flanked by a snowman inside the snowdome.

Hollywood used painted corn flakes for snow scenes. *Citizen Kane*'s snowman was made out of Styrofoam. It's so much easier

just *drawing* a snowman. Animated movies of snowmen have been produced in every corner of the world, including Albania, Bulgaria, the Czech Republic, England, and Germany (all titled *The Snowman*). Walt Disney gave the snowman a gig in one of his first silent shorts, the *Alice* comedies made in the 1920s. During an Uncle Tom Cabin Show, Alice is bopped in the head and dreams of being in Snowland. There, Pete the

The Snow Man *(1932), a theatrical short cartoon directed by Ted Eshbaugh, actually gives us the first example of a killer snowman.* VINTAGE CARTOON CHANNEL

Bear chases her across ice floes and then they make snowmen. Despite all this, Mickey would eventually outshine Alice, and the *Alice* series would conclude.

Movies around the turn of the century always had the snowman coming to life. This included the Swedish cartoon *Kalle's Dream* (1916), which depicts the earliest animated snowman. Before that only *live* snowmen appeared on film, through the use of ground-breaking special effects. And LIVE they were. One example was *The Snowman* (1912), a ten-minute black and white silent, in which a man dreams that a snowman comes to life and chases him down. A more important endeavor from this era would be the earlier *The Snowman* (1908), by Wallace McCutcheon and starring Bobby Harron. The movie opens innocently enough with children making a snowman. After dark, the snowman comes to life and frightens an African-American chicken thief into turning his live loot loose. The snowman then breaks into a schoolhouse and steals the stove. In the morning, an angry mob, led by the chicken stealer, finds a sleeping snowman and bludgeons him with a steel pipe. Only

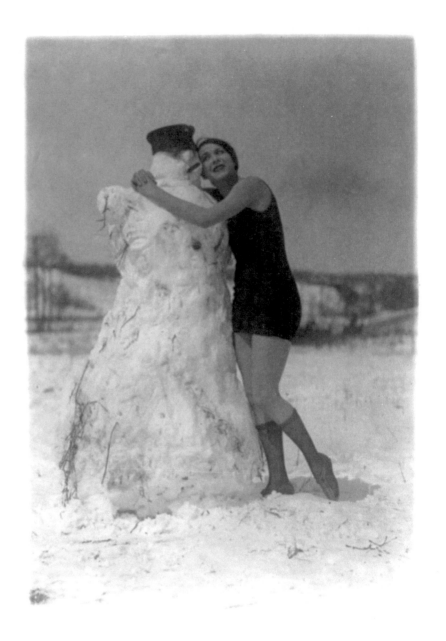

*"What it takes to melt a snowman this young lady has—Miss Fritzi Ridgeway" (1924).* LIBRARY OF CONGRESS, PRINTS & PHOTOGRAPHS DIVISION, PHOTOGRAPH BY HARRIS & EWING

four minutes in length, the film manages to cover a lot of ground, including racism, manslaughter, and grand larceny.

Stepping back even further in time to 1899, the film company Star Films released *La Statue de Neige* (a.k.a. *The Snow Man*). Anyone getting up for popcorn would have missed the whole movie—at about twenty-five seconds it was no epic, but nevertheless it was an important advancement in cinematic history. Its director, Georges Méliès, was one of the world's pioneers of film, and today he is considered an early genius of special effects. Unfortunately most of his movies are gone. *The Snow Man*, along with several huge crates containing the negatives of films from his seventeen-year career, was destroyed under orders of Méliès himself, in a moment of anger when his film business collapsed.

But Méliès's wasn't the first piece of celluloid with a snowman. That honor goes to *Snow Men* (1896), one of the first moving pictures ever and the earliest casting of a snowman. The historic film captures three minutes of street urchins creating a snowman. Not many have seen the movie, so movie reviews of the snowman's rookie performance are nonexistent.

Even this, however, was not the snowman's first taste of show biz. The snowman, predictably, began his career in vaudeville. Under the watchful eyes of Professor Carl Marwig, students at the Academy of Music in New York City put on a "new, brilliant programme" called the *Children's Carnival and Ball*. Cited in 1878 in the *New York Times* as "wonderful," the snowman's big scene comes in the fourth act, after the grand march and procession followed by, of course, the Spanish national castanet dance. It is then that The Jee Queen, assisted by "her court of snow-men," is brought out in a sleigh drawn by polar bears. Before anyone can pose the question, "Who will dance a comic snow polka?" spontaneous polka activity erupts, bringing down the house. That's entertainment.

That humble beginning on Broadway opened the floodgates to hundreds of theatrical productions revolving around snowmen. The most successful was Erich Korngold's ballet/pantomime *Der Schneemann* (*The Snowman*) at the Vienna Court Opera in 1910. Written at the age of eleven, Korngold's first composition caused a sensation and would start his emergence as a renowned musical figure of the twentieth century.

But the snowman really had his day in the sun on television. It was an old hit from 1950 about a magic snowman, around twenty years before he would become FROSTY, that resulted in the snowman on our television sets every Christmas season since 1969. The song was born in 1949 after the two songwriters watched Gene Autry sell two million copies singing the earworm, "Rudolph, the Red-Nosed Reindeer"—well before any of the holiday specials arrived on the screen. Nelson and Rollins immediately went to work on something equally catchy. By the next year, they pitched "Frosty, the Snowman" to Autry, who was just all too anxious to follow up his holiday success from Rudolph the year before (They brought plan B along as well—the Easter ballad, "Here Comes Peter Cottontail.") There was obviously some magic in that Frosty song, as it was a hit and made the Top Forty chart. Many recorded the song in 1950, aside from Jimmy Durante, the most famous version, with three making the charts: Nat King Cole, Guy Lombardo, and Gene Autry. The Frosty song enticed many big-name artists into recording a cover over time, including Bing Crosby, Perry Como, Ray "The Tinman" Bolger, Esquivel, Red Foley, Fats Domino, Ella Fitzgerald, Loretta Lynn, the Jackson Five, the Beach Boys, the Cocteau Twins, the Roches, the Ronettes, the Ventures, and Willie Nelson. "Frosty" even inspired other snowman songs. The Jaynetts recorded the promising "Snowman, Snowman Sweet Potato Nose." Petula Clark had a hit in 1952 with "Where Did the Snowman Go," a song Groucho Marx later sang the on *The Ernie Kovacs Show*. The next year Gene Autry covered the song again—the only snowman

*Frosty was based on initial drawings by* MAD *magazine cartoonist Paul Coker, Jr., who is still asked by children to draw Frosty, which, he says "luckily is just three circles."*
ORIGINAL ART CREATED FOR BOOK IN 2006, COURTESY OF THE ARTIST, PAUL COKER, JR.

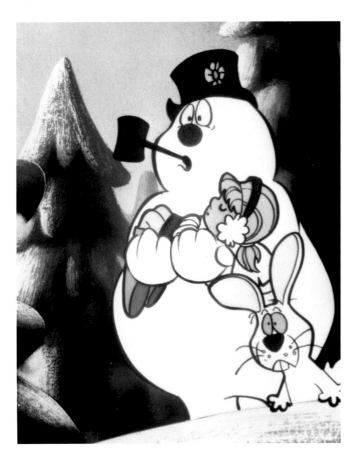

*Modern Frosty.*
COURTESY OF RICK GOLDSCHMIDT ARCHIVES, RANKINBASS.COM

song Autry hasn't covered is Marilyn Manson's "Suicide Snowman." All this Frosty overexposure precipitated a sarcastic backlash song in 1953: "Frosty, the Defrosted Snowman."

The song "Frosty, the Snowman" started a sensation, and the Frosty thing began to snowball. Frosty games, toys, and shirts hit the stores. A Little Golden Book of Frosty was published. Appearances in Thanksgiving Day and Christmas parades followed.

In 1954 a three-minute animated short of Frosty aired on TV. In the long-form *Frosty the Snowman*, our protagonists set off on a chase to the North Pole, where nobody learns more about themselves. The 1969 project became a holiday standard and, no doubt, was beloved by millions, securing the snowman's place amid other non-religious Yuletide icons like Santa, the Grinch, and Rudolph.

The Frosty from the tune resembles a snowman in a children's book that preceded the famous song by five years. *Snowy the Traveling Snowman* was written by Ruth Burman in 1944. It's about a magical singing snowman, who also dances and plays with children and, like Frosty, has coal for eyes, wears a high silk black hat, and smokes a pipe.

A passage from this rare Snowy book declared: "The snowman came bumpity-bump down the hill." The last line from Frosty

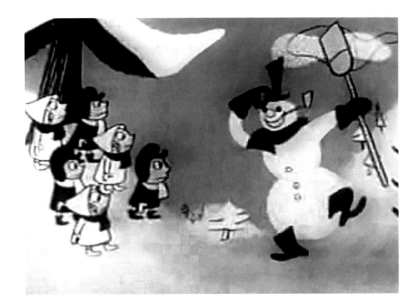

the song concludes: "Thumpety-thump-thump, over the hills of snow." Without question, thumpety-thump-thump sounds exactly like what someone would use if they really liked bumpity-bump-bump but couldn't use that exact phrase. Snowy, like Frosty, makes a promise in the end to return again someday.

Anyhoo, there were four sequels to the Frosty TV special, all with impressive stars. The last, *The Legend of Frosty the Snowman* (2005), starred the voices of Burt Reynolds and the guys from *SpongeBob Squarepants*. Before that was the 1992 sequel *Frosty Returns*, with Jonathan Winters and John Goodman, also bringing to the fold the lead singer of DEVO, Mark Mothersbaugh, to create more songs. Incidentally, that same year Frosty also starred in *The Spirit of Christmas*, a cartoon short originally called *Jesus vs. Frosty* made by the creators of *South Park*, Trey Parker and Matt Stone. In 1979 *Rudolph and Frosty's Christmas in July* aired, starring Mickey Rooney, Ethel Merman, Red Buttons, and Shelley Winters. The sequel before that was 1976's *Winter Wonderland* starring Shelley Winters, Dennis Day, and Andy

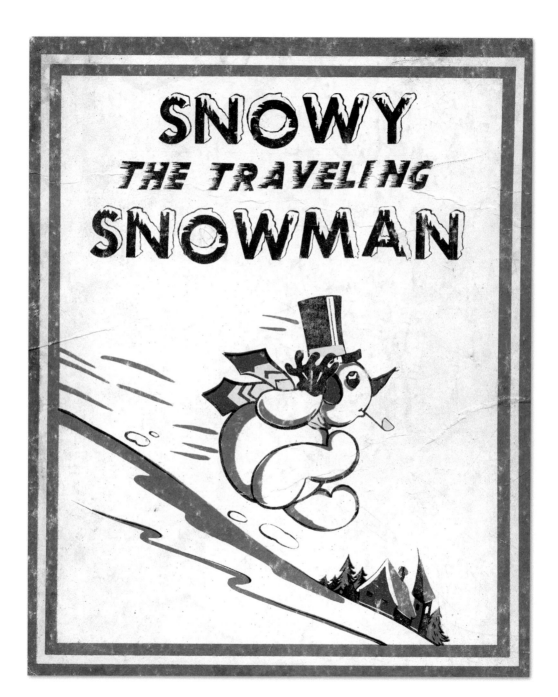

Snowy the Traveling Snowman, *by Ruth Burman, 1941.*

Griffith playing himself.

We can only speculate what our perception of the snowman would be if Jack Nelson and Steve Rollins had not written their hit single. Frosty permanently transformed the snowman's image into the homogenized figure we see now in gift shops. It was Frosty who would become the most famous snowman, undoing Burl Ives's masterful performance as the high-brow classy snowman in *Rudolph, the Red-Nosed Reindeer* five years earlier, although he is the standard by which other snowman narrators are now measured. In *A Very Muppet Christmas*, the snowman narrator Mel Brooks is chided as a "Burt Ives wannabe." *Rudolph* was back in 1964, the same year that the short *Help! My Snowman's Burning Down* was nominated for an Oscar, a performance that obviously caught the eye of legendary film director Richard Lester who, the following year, cast the snowman as the spy in the Beatles' hit *Help!*

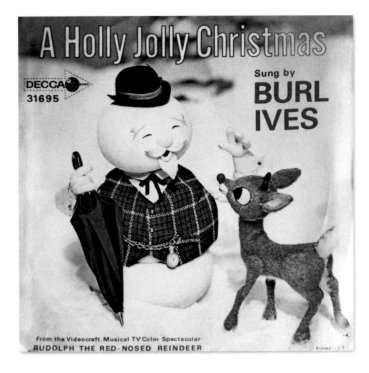

COURTESY OF RICK GOLDSCHMIDT ARCHIVES, RANKINBASS.COM

# CHAPTER FOUR

# THE GOLDEN AGE OF ADVERTISING

*Snow Sells*

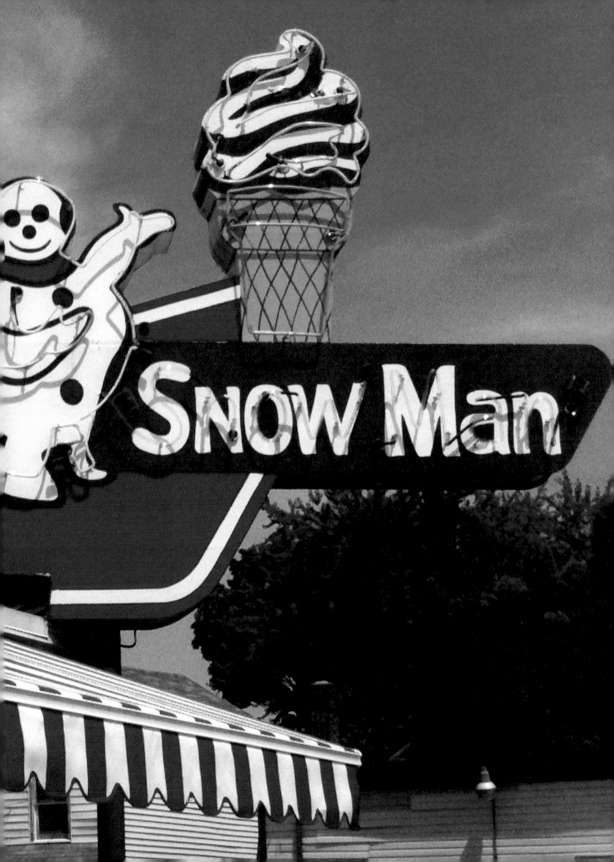

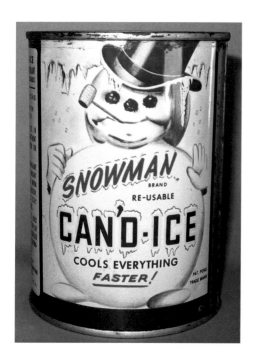

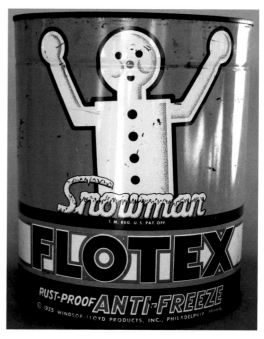

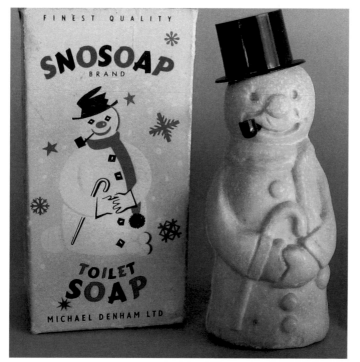

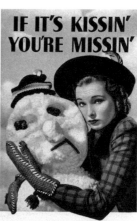

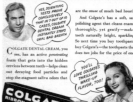

**T**hroughout the twentieth century the snowman enjoyed as much airtime as anyone. This was not a reflection of the snowman's success in Hollywood as much as his success on Madison Avenue; he has appeared nonstop in television commercials since their inception.

The snowman hocked everything from soup to soap, from insurance to asbestos. The ultimate pitchman, the snowman was without peer, perched on top of advertisers' A-list; he sold oatmeal, tractors, Cadillacs, children's clothes and booties, even his own flesh and blood: canned ice. This is because ad agencies found the snowman easy to work with, an easy tie-in to anything. Any cold weather product to defrost or freeze was a likely candidate. Ice crushers, antifreeze, snow shovels, insulation for the home, winter shoes—all were endorsed by snowmen. Then there

**FACING PAGE (CLOCKWISE FROM TOP LEFT):** *A popular product (in the '40s and '50s) called Snowman's Can'd Ice. Snowman brand antifreeze. Colgate toothpaste ad originally appeared in* Woman's Day *and* Saturday Evening Post, *1953. Snosoap—now you can shower with the snowman.*

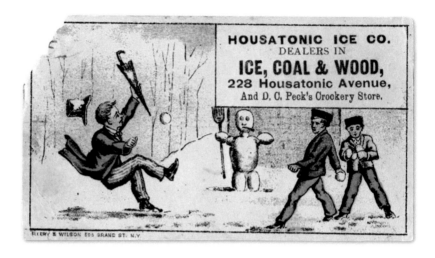

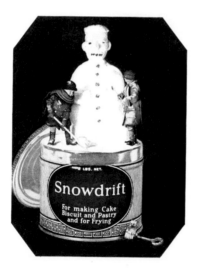

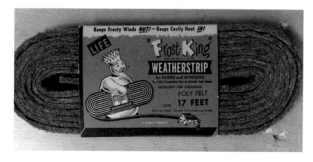

is the holiday connection. You think holidays, you think Santa and snow. But, unlike Santa, the snowman has conveniently distanced himself from any particular denomination, broadening his demographics and making him a more sensible choice. Marketing departments reasoned that since snowmen are made of snow, anything white and powdery was game, too. This meant manufacturers of salt (Snow White), flour (Snoflour), farina (Cream of Wheat), sugar, soap flakes (Ivory Soap), anti-dandruff products, ice cone machines (Hasbro), toothpaste (Colgate), refrigerators (Copeland), and even cocaine

HOLIDAY SNOWMAN

TRADITIONAL
OR DEBONAIRE
ATTIRE

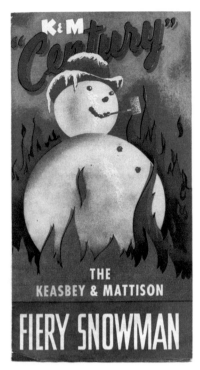

K&M "Century"

THE
KEASBEY & MATTISON

FIERY SNOWMAN

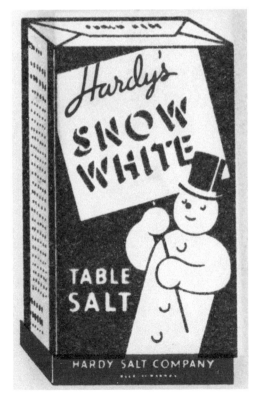

Hardy's
SNOW
WHITE

TABLE
SALT

HARDY SALT COMPANY

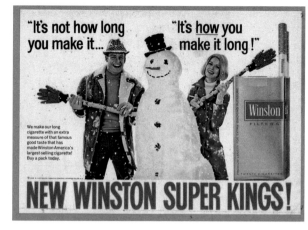

"It's not how long you make it...

"It's how you make it long !"

We make our long cigarette with an extra measure of that famous good taste that has made Winston America's largest-selling cigarette! Buy a pack today.

Winston
FILTERS

# NEW WINSTON SUPER KINGS!

Chivas Regal • 12 Years Old Worldwide • Blended Scotch Whisky • 86 Proof.
General Wine & Spirits Co., N.Y.

The farmer whose estate
just melted away...

(advertised in the form of T-shirts) all lined up for the snowman's services.

With the snowman you were starting with a clean slate, a PR's dream, a totally pliable public image to suit any account. Want your clothes clean and white, like a snowman? Selling cigarettes? The snowman exudes "cool, fresh air." Even when he's smoking up to two packs a day.

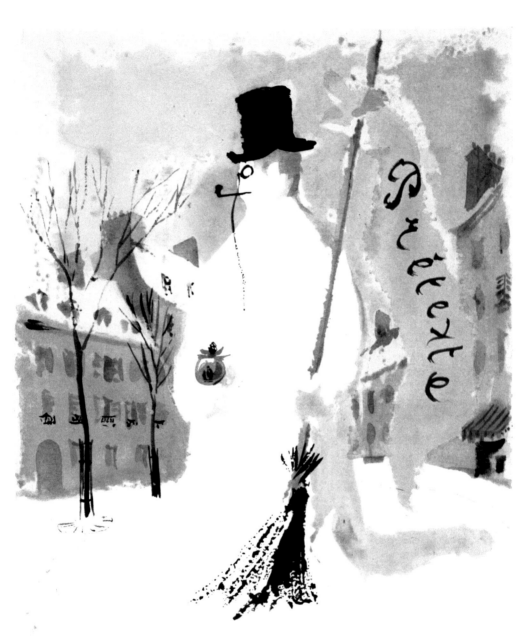

# LANVIN PARFUMS

*Originally appeared in* Plaisir de France, *1955.*

# Great American Customs—

## ...BUILDING THE SNOW-MAN AND ENJOYING SWIFT'S BROOKFIELD SAUSAGE ON WINTRY MORNINGS!

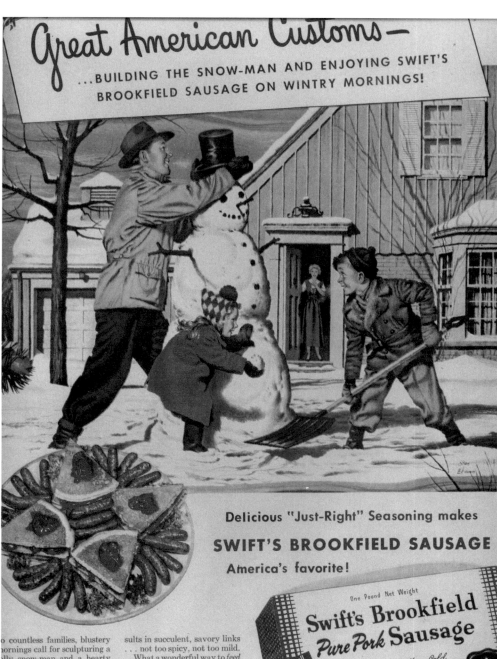

Delicious "Just-Right" Seasoning makes

## SWIFT'S BROOKFIELD SAUSAGE

America's favorite!

o countless families, blustery mornings call for sculpting a olly snow-man and a hearty izzling breakfast of Swift's Brookfield Sausage.

They want America's favorte because *the seasoning is just-right"*. For Swift's delicate blending of fine spices with elected cuts of pure pork re-

sults in succulent, savory links ... not too spicy, not too mild.

What a wonderful way to *feed your family energy!* For Swift's Brookfield Sausage is rich in high-quality proteins—rich in vitamin B. And these links or meat for patties are *made fresh daily* in spotless Swift kitchens from coast to coast.

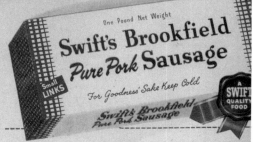

One Pound Net Weight

### Swift's Brookfield Pure Pork Sausage

Small LINKS

*For Goodness' Sake Keep Cold*

Swift's Brookfield Pure Pork Sausage

A SWIFT QUALITY FOOD

FEATURED THIS WEEK AT FINE FOOD STORES EVERYWI

Personal hygiene was also crucial, and the snowman sold per-fume and dental cream. (Colgate's 1953 campaign told women that "if it's kissin' you're missin', better look to your breath," because "it's sno' wonder you're getting the cold shoulder from men.") Weight loss also turned out to be the snowman's niche—he sold girdles for the Jantzen Lingerie company in the 1950s.

"The snowman never melts in snapshots," Kodak cameras promised, claiming to be the family camera of choice. And how should a mother and daughter broach the uncomfortable sub-ject of tampon use (Kotex, 1949)? Throw a snowman in the mix to break the ice—a whole lot better than having Dad there. The snowman provides a feeling of family closeness. Someone had to build him, which means collaboration, bonding—how could that not lead to girl talk? Frequently the snowman is there just to symbolize goodwill, honesty, purity. He is naked, but not sexual. He's got nothing up his sleeve. You'd buy a car from him.

It's no wonder the snowman is the logo for dozens of estab-lishments for a wide array of industries, companies like Frost King (home improvement products), Snow's milk, and the U.S.

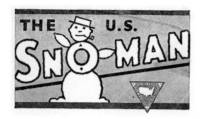

Package delivery service.

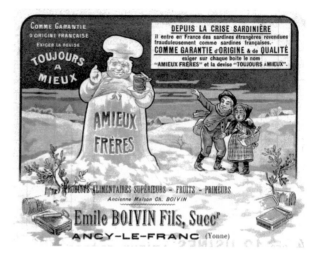

French sardine ad (1930s).

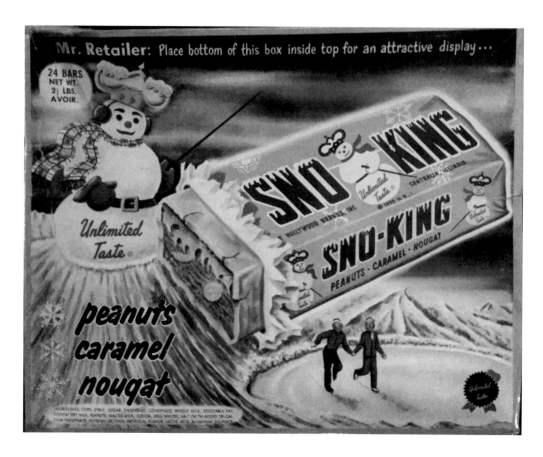

Sno-Man delivery service. He has that certain savoir faire that translates across international lines, making him a logical choice whether selling sardines (Amieux Frères) in France or beef bouillon (Bovril) in the States. Friendly, fat, and identifiable is an advertising formula used by many copycats like the Michelin Man, the Stay Puft Marshmallow Man, the Pillsbury Doughboy, the Maytag Repairman, and Mr. Bubble—all poor men's snowmen. It was one of the big lessons for big business: If the product could be tied into an everyday figure, all the better. Companies like Quaker Oats made their trademark friendlier and more approachable, switching from an uptight, humorless salesman to the plump, smiling fellow with the silly hat, much like a snowman.

It was in 1919 that Beech-Nut Ginger Ale gave him his first big break as a walking snowman, hoisting a tall, icy glass of their finest. The snowman's appearance came at a time when the concept of logos was an outside-the-box idea.

Before the snowman became a logo, he appeared simply as a pitchman, appearing regularly in magazines, sometimes holding up a product, sometimes just smiling at the camera. When it

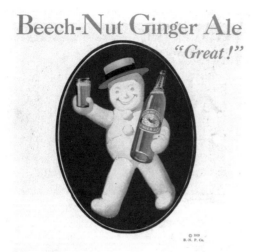

# Beech-Nut Ginger Ale
## *"Great!"*

New Ginger Ale with a New *Flavor!*

© 1919
B.-N. P. Co.

**ABOVE:** *The snowman has arrived as a viable pitchman, 1919.*

# THE CHILDREN'S FAVOURITES

*"THIS'LL KEEP YOU WARM!"*

FRY'S
PURE
BREAKFAST
COCOA
J.S.FRY & SONS, LP

# FRY'S CHOCOLATES & PURE BREAKFAST COCOA

## Long Distance turns cold prospects into hot sales leads

No doubt about it—Long Distance is a mighty handy sales tool. With it, you can reach almost anywhere, any time. It's great for turning up hot sales leads—or tracking them down.

"Recently a 'cold' call to a Kansas City grain elevator sold a $37,000 Aeroglide grain drier for us," reports James F. Kelly, president of Aeroglide Corp. of Raleigh, N. C. "I picked my prospect carefully, did a little selling, and asked for the order. The call cost me $4.50."

Try selling by Long Distance in your business. You'll find it pays off big!

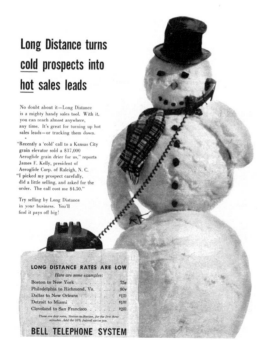

| LONG DISTANCE RATES ARE LOW | |
|---|---|
| *Here are some examples:* | |
| Boston to New York | 75¢ |
| Philadelphia to Richmond, Va. | 80¢ |
| Dallas to New Orleans | $1.25 |
| Detroit to Miami | $1.90 |
| Cleveland to San Francisco | $2.90 |

*These are day rates, Station-to-Station, for the first three minutes, and the 10% federal excise tax.*

**BELL TELEPHONE SYSTEM**

## *Everyday's a Holiday—*
### since our Doctor recommended double-action Phillips'

*What a hit this laxative antacid makes!*

Holiday or no holiday . . . all of us overindulge in eating or drinking every once in a while. Your stomach usually becomes excessively acid and you suffer the annoying symptoms of heartburn, sour stomach, headachy, upset feeling.

*That's* when you'll be mighty grateful for the speedy action of Phillips' Milk of Magnesia. Taken at bedtime with water, Phillips' helps end that restless, fretful feeling caused by acid indigestion. You sleep soundly, perhaps better than you have in years. And in the morning you wake up feeling refreshed and full of life.

It's this *double-action* of Phillips' Milk of Magnesia that does the job:

*1. As an acid stomach alkalizer, Phillips' is one*

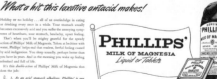

**PHILLIPS'**
MILK OF MAGNESIA
*Liquid or Tablets*

GENUINE
PHILLIPS
MILK OF
MAGNESIA

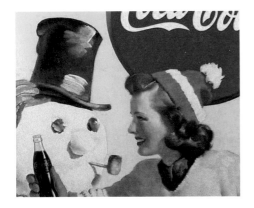

**LEFT:** *The real thing back in 1941 (Coca-Cola).*

**BELOW:** *Ad for Miller High Life beer.*

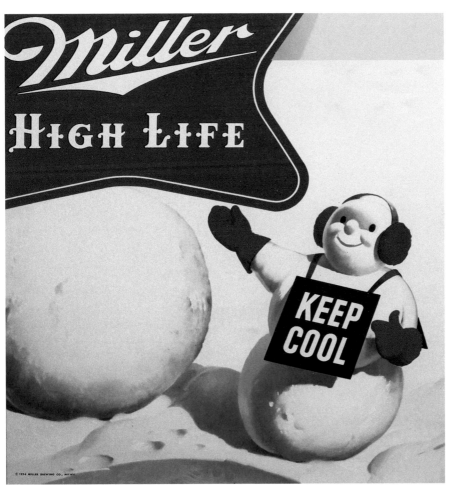

seemed like the whole world was moving to America and creating new consumer markets, savvy merchandisers increased their promotion and started spending big bucks. The snowman's first taste of the print ad big leagues was in 1917, as a spokesperson for the Milburn Wagon Company, makers of that new sensation, the automobile. The company's selling point was that they had manufactured the only lightweight electric car—and at the lowest price, $1,685, exploiting the snowman as an "everyman."

How the snowman reached marketing superstardom is not rocket science. There are no royalties—the snowman was public domain since day one. When that eleventh hour comes and there's nothing left in the budget, it's time to wheel in the guy whose public approval marks will always exceed his human counterparts', who doesn't mouth off, and never has a run-in with the tabloids.

*Campaign matchbook for a court clerk. Based on the earlier artwork to the right, one can see how the court clerk placed his face on the snowman.*
PERSONAL COLLECTION OF THE AUTHOR THANKS TO SATURN PRESS OF MAINE

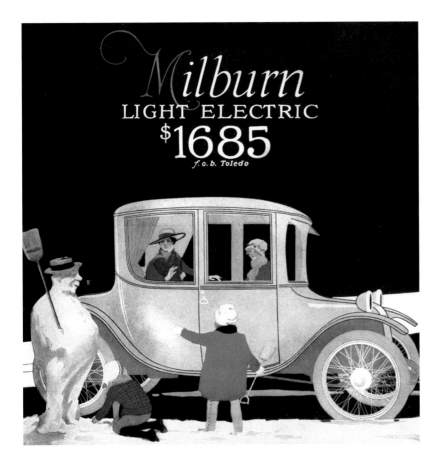

*Originally appeared in* The New Country Life, *1917.*

The biggest niche in snowman retail is the artificial snowman industry. Plastic, Styrofoam, glass, wood, wool, silk, ceramic, Lenox, wax, rubber, golf balls, cheese balls, white chocolate, and marshmallows. He has been lit up, blown up, hung up, strung out, and hot glued. Holiday decorations, Christmas ornaments, oven-size snow domes, business ties, jewelry, leaf bags . . . if it can be bar-coded, it can be a snowman. Now mass-produced snowmen are becoming more elaborate. Is this retail's way of getting us to doubt our ability to make snowmen from scratch with household items and resort to artificial snowmen?

## Watch Winter Melt Away!

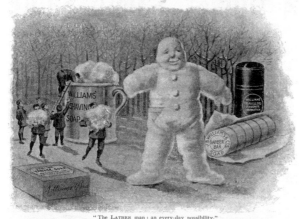

It stands alone — *literally—actually.*

"The LATHER man ; an every-day possibility."

## WILLIAMS' SHAVING SOAP

It's the human connection we all feel that makes the snowman the darling of Madison Avenue. He triggers thoughts of happier times playing in the snow. Snowmen are fun because they are easy to make, a primal instinct, an innate skill. Children are not going out making clocks. There's not a whole lot of thinking involved. That was not always the case.

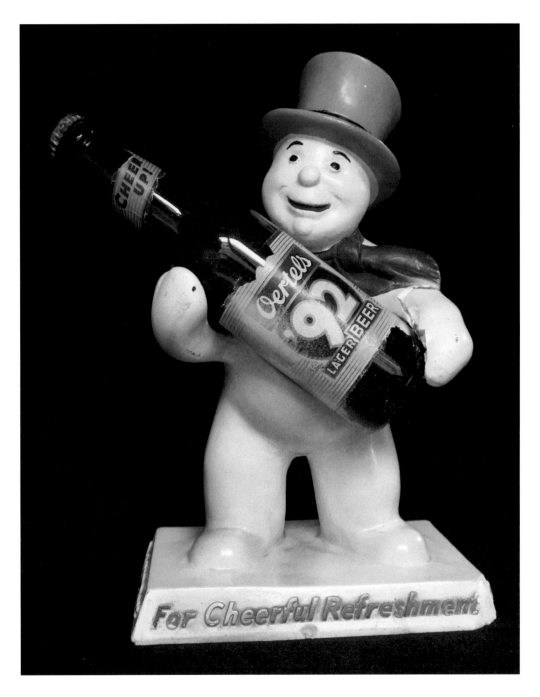

*Display for Oertel's beer.*

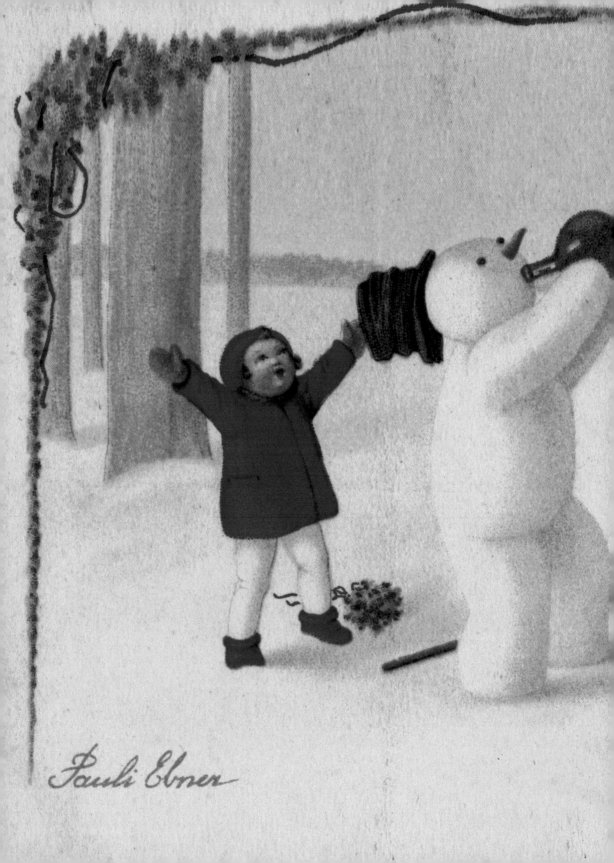

Pauli Ebner

CHAPTER FIVE

# THE DRUNKEN
# W. C. FIELDS YEARS

*Rare 1904 greeting card with metallic ink.*

The snowman's ad accounts quadrupled around 1934. Funny how prohibition ended in 1933. The phenomenal success of the snowman as a pitchman can be traced back to this event in American history, as he would right after this represent most of the country's leading liquor companies, including Miller, P. Ballantine and Sons, Rheingold, Schlitz, Schenley Industries, Oertel, Fort Pitt, Mount Whitney (beer), Chivas Regal (scotch), and both Jack Daniel's and Four Roses (whiskey).

It was around this time that the snowman established his reputation as a fun drunk. He would clean up his act for advertisers—wearing silk scarves and classy top hats—but before that, he was a pickled, skirt-chasing, under-the-table lush in postcards and illustrations.

A disproportionate amount of holiday greeting cards from the 1900s to the 1930s show the snowman cavorting with women, drinking with minors, and loitering. Forever at the forefront of major changes in our country, he mirrored America's drinking

A MERRY CHRISTMAS TO YOU

**ABOVE:** *Trading stamp of misguided youth taking out their angst on the snowman.*

**LEFT:** *Street thugs holding up a snowman at gunpoint.*

binge and fascination with smoking. While these depictions were, in a way, humanizing, seeing a tipsy snowman chasing a girl with a stick does not sit well with us today. The popularity of these cards testifies to a time when our society embraced this persona and found it very funny—the public could not get enough of the snowman getting plastered.

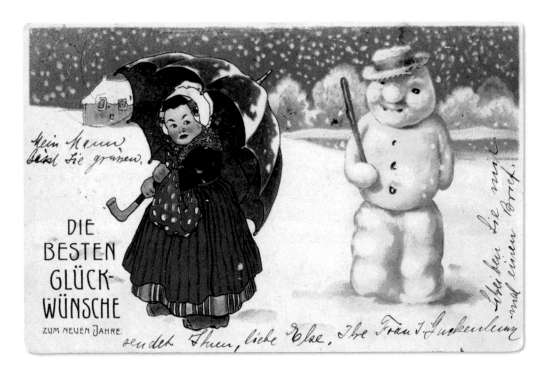

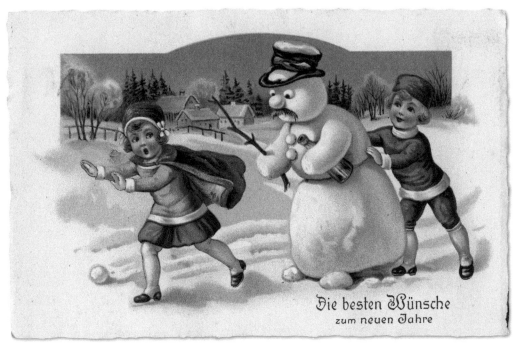

**TOP:** *One of the "Hey, that snowman looks like W. C. Fields" cards.*
**BOTTOM:** *Chasing a girl with a bottle in one hand and pointed stick in the other, 1927.*

*The snowman and comic great W. C. Fields both wore straw hats and crimson noses in their silent movies. By the '30s and '40s, Fields started to round out his look, becoming rounder and switching to a more aristocratic look. The two were like twins. (One difference: W. C. Fields was known to hate the holidays. Ironically, he passed away on Christmas Day.)*

**LEFT:** *A light-up toy of a lit snowman.*

**ABOVE:** *The snowman on a matchbook for the Subview Trailer Park in Wichita, Kansas.*
ILLUSTRATION BY T. N. THOMPSON, 1957

So what sent the snowman into a tailspin that would become his lost weekend? Well, by 1908 there was already clear evidence of a drinking problem. In Wallace McCutcheon's silent movie *The Snowman*, a chain-smoking snowman swigs whiskey and is promptly flogged by the townspeople. Was this in the script? No one knows for sure. The two earliest public displays of smoking and drinking are in an 1898 illustration, in which the snowman has an armful of champagne (he's obviously on his way to some office party) and a label from an 1890 bottle of whiskey. At this time there were a disturbing number of cards illustrating the snowman being abused and humiliated by persons from all walks of life. Early popular postcards show the snowman pelted with snowballs by a gang of wayward youths, plowed by speeding sledders or pig-driven toboggans, bludgeoned by two-by-fours,

stomped on by tots, held up at gunpoint by little girls, stabbed with brooms, and posing in photoshoots with cats . . . it is clear that the public drove him to drink. In addition, the snowman appears in ads suffering from every embarrassing personal hygiene problem imaginable: dandruff, gas, hangovers, constipation, bad breath, etc. From polls taken at the turn of the century by *Journal of American Folk-Lore*, "making the snow-man a target" was one of a boy's favorite activities, right up there with

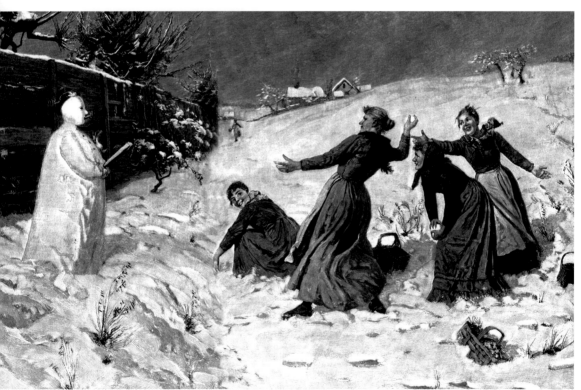

*Pelting a snow cop who can't fight back in this rare late 19th-century German engraving by Hans Dahl.*

squat tag and stealing hot bis-
cuits. The 1890s *Young Folk's
Cyclopædia of Games and
Sports* describes a variation of
the nineteenth-century game
Aunt Sally, in which children
can score points by throw-
ing snowballs at a snowman.
The lowest point, however,
would have to be the holiday
card showing Santa Claus in a
convertible racing car about to
run over a horrified snowman.
The snowman is screaming

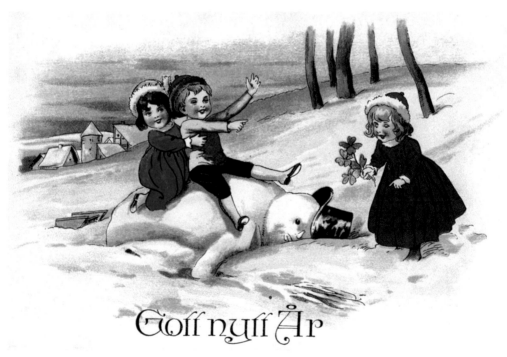

*Typical of the cards from this era. Where's the adult supervision?*

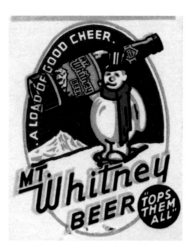

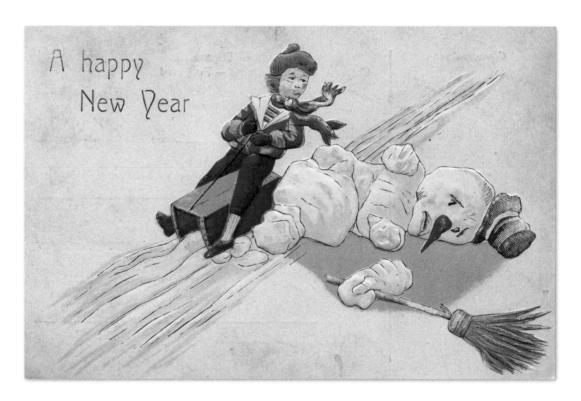

*Happy New Year? Not for the snowman. Greeting card, 1908.*

for dear life and looks ridiculous. The snowman's psyche had taken quite a beating. We built him up only so we could, apparently, use him as a piñata.

To find clarity on this subject, we of course turn to metered poetry. The following is from one of the renowned Canadian P. K. Page's poems, "The Snowman" (late twentieth century):

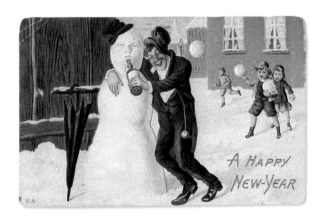

*Greeting card, 1912.*

## What a terrible fix I'm in!

*Ad for Four Roses Whiskey.*

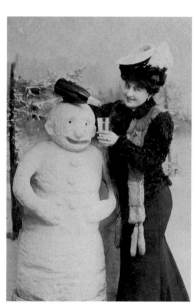

*And so it begins.*

*i. White double O, white nothing nothing . . .*
*ii. Now three-dimensional. Abstract. Everyman.*
*Of almost manna, he is still no man.*
*No person, this so personal snowman.*

In 1921, at the depth of the snowman's jag, the poet Wallace Stevens attempted to capture the snowman's feelings of worthlessness and anonymity in his famous poem "The Snow Man":

*For the listener, who listens in the snow,*
*And, nothing himself, beholds*
*Nothing that is not there and the nothing that is.*

Stevens so perfectly captures the snowman's inner turmoil—his public perception was (and still is) the hapless sap waiting at

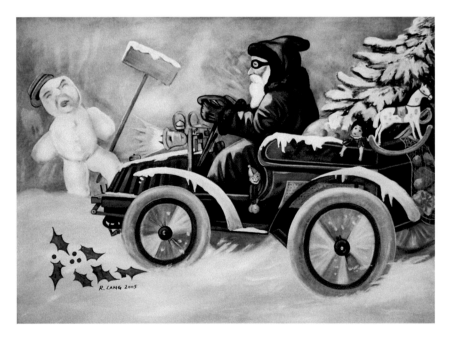

*Santa lashing out and driving over a snowman. Painting based on rare HTLs (hold-to-light see-through postcards).* ARTWORK BY RAY LANG © 2007

the bus stop who gets splashed by the passing bus. Because of his anonymity, the snowman might be different to everyone, but he is nobody to everybody. We can all relate to him. He's the last man picked. He *is* the everyman.

*Rare plastic 3-D greeting card of drunk snowman.*

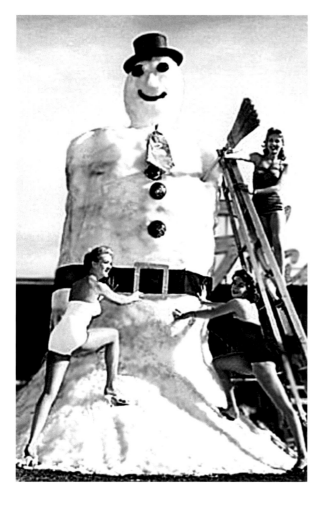

*The snowman's womanizing would continue throughout the Hollywood years, showing up on cheesecake publicity shoots, calendars, and matchbook covers. He would flirt with bikini-clad starlets and the likes of Dinah Shore, Esther Williams, and Shirley Temple.*

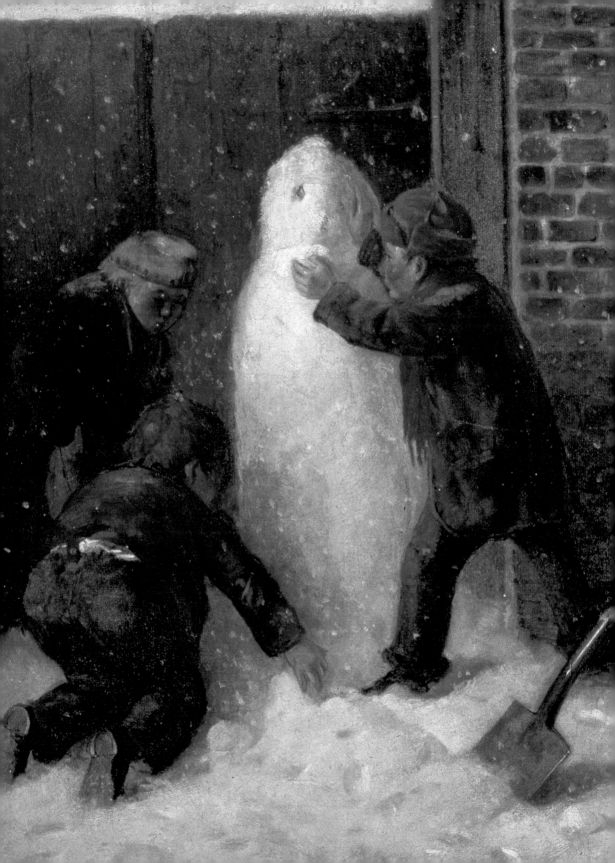

# CHAPTER SIX

## SNOWMEN IN THE ARTS

**ABOVE:** *David Humphrey,* Snow Guys, *2006. Acrylic on canvas.*
COURTESY OF THE ARTIST DAVID HUMPHREY. REPRESENTED BY FREDERICKS AND FREISER, NY

**PREVIOUS SPREAD:** The Snowman *(oil), Edward Charles Barnes (1855–1882).*
CADOGAN GALLERY, LONDON, UK. BRIDGEMAN IMAGES

**B**efore the snowman became a textbook alcoholic, he was an icon in both high culture and art, inspiring both writers and artists alike who sought to flesh out his soul. Painters painted him. Songs were sung about him. Books were written about him. The snowman was one of the most important inanimate objects in art.

No group loves the snowman more than flowery writers, providing them with a bottomless well of metaphors for everything from death to birth to, of course, unrequited love. Wallace Stevens's "The Snow Man" inspired everything from a 1995 movie of the same name to Jasper Johns's renowned painting *Winter*.

Other brushes with high-brow art include Joan Miro's *Blue II*, from the triptych *Les trois bleus*, which, whoever you ask, looks like a melted snowman. When Miro's masterpiece was completed in 1961, the famous artist confided that his painting "was the culmination of everything I had tried to do up to then." Today a handful of distinguished artists focus their work around the theme of the snowman.

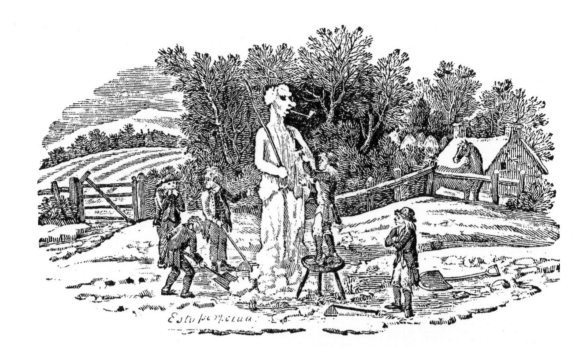

**TOP:** *The earliest picture of anyone making a snowman. From* History of British Birds, *published in 1797. Thomas Bewick cut this out of wood in the late 1780s. Notice the snowman smoking a pipe and the words on the bottom left, "Esto Perpetua," meaning "Let it endure forever," a popular motto at the time. The artist was referring to his own artwork as the only way to capture a boy's childhood or a snowman's existence.* BY PERMISSION OF THE SPECIAL COLLECTIONS AND ARCHIVES LIBRARIAN, ROBINSON LIBRARY, UNIVERSITY OF NEWCASTLE UPON TYNE

**MIDDLE:** *Not Joan Miro's* Blue II *from the triptych* Les trois bleus *but a still-life of a melted snowman inspired by him.* ARTWORK BY BOB ECKSTEIN, 2007

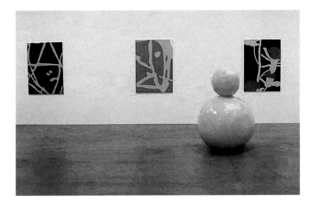

**BOTTOM:** *Gary Hume.* Back of a Snowman (Pink), *2000. British artist Gary Hume has followed in the footsteps of Fischli and Weiss by presenting the snowman as art.* © GARY HUME COURTESY OF MATTHEW MARKS GALLERY, NEW YORK

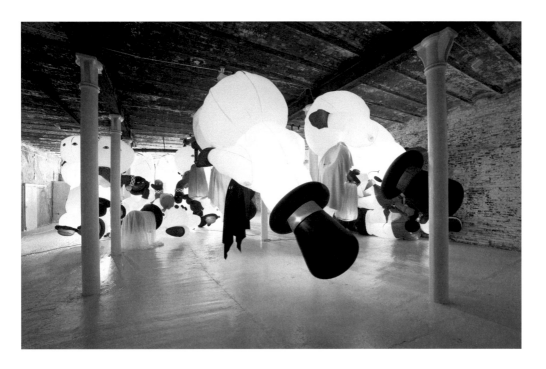

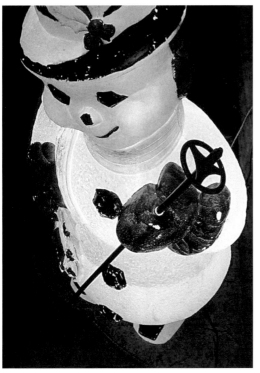

*David Humphrey,* Snowman in Love, *2006, modified inflatable snowmen and paintings.* COURTESY OF THE ARTIST, DAVID HUMPHREY. REPRESENTED BY FREDERICKS AND FREISER, NY

*Untitled, 2010, by photographer Manu Geerinck.* PHOTO AND PERMISSION COURTESY OF THE ARTIST. MANUELGEERINCK.COM

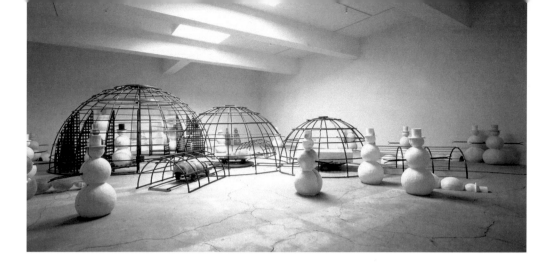

*Dennis Oppenheim. Snowman Factory, 1996. Rolled aluminum, casters, rubber molds, cast fiberglass castings. 10 ft. height x 50 ft. width x 50 ft. length.*
PHOTO: ACE CONTEMPORARY, LOS ANGELES, CALIFORNIA. COURTESY OF DENNIS OPPENHEIM ESTATE

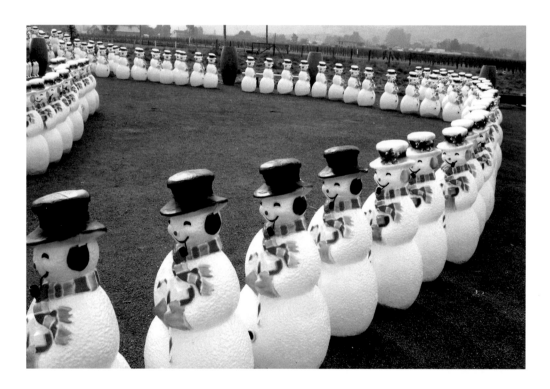

*Installation by Ingrid Butler. Some of the most important contemporary artists contributed to this chapter. They include Olaf Brenning, Ingrid Butler, Peter Fischli, photographer Manu Geerninck, Gary Hume, David Humphrey, Dennis Oppenheim, Keith Tyson, choreographer Jasmin Vardimon, and David Weiss.* PHOTO BY INGRID BUTLER

*Snowman*, by renowned Swiss artists Peter Fischli and the late David Weiss, was conceptualized in 1987, executed in 1989, and first displayed at a power plant in Germany, in 1990. Then in 2017 the refrigerated snowman was again celebrated and began touring the country, starting at the Art Institute of Chicago and ending in MOMA in New York City. Fischli explained how the snowman-in-a-box concept works: "A copper snowman is used as a base, and filled with cooler liquid, and the box is filled with humidity and builds out after four or five days." Basically, the condensed water ices up and makes a snowman. More importantly, framing the snowman as modern art brings the snowman back to its deservedly lofty status.

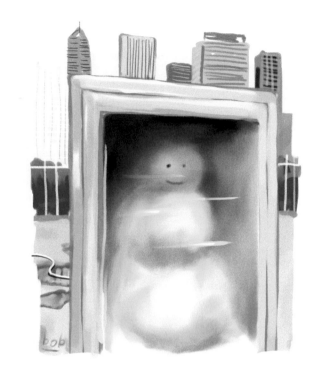

Snowman *installation by Peter Fischli and David Weiss, 2017— close-up. On the roof of the Art Institute of Chicago.*
ILLUSTRATION BY BOB ECKSTEIN, ORIGINALLY PUBLISHED IN *THE NEW YORKER,* 2017.

*Gary Hume.* Snowman (Red), *1997, Cibachrome.*
© GARY HUME COURTESY OF MATTHEW MARKS GALLERY, NEW YORK

*Gary Hume.* Back of a Snowman (White), *2002. Painted bronze.*
*118⅞ in. height x 82¹¹⁄₁₆ in. diam. x 43⁵⁄₁₆ in. diam. (302 x 210 x 110 cm)*
© THE ARTIST PHOTO: STEPHEN WHITE COURTESY OF JAY JOPLING/ WHITE CUBE (LONDON)
© GARY HUME COURTESY OF MATTHEW MARKS GALLERY, NEW YORK

Snowman, *2004, Customized wood coffin, 19 x 39 x 86 in. Olaf Breuning. A wonderful snowman coffin.* PHOTO AND PERMISSION COURTESY OF THE ARTIST

Even more impressive is the snowman's universal appeal in literary circles. He appears in many different genres of publishing, and enough titles to occupy their own bookstore. Titles include *Snowman: A Novel* (Thomas York, 1976), *The Snowman: A Novel* (Charles Haldeman, 1965) *The Snowman's Children: A Novel* (Glen Hirshberg, 2003) and the real curveball, *Socrates, the Snowman* (Doris Gasser, 1980). Included in this stack would be literary heavyweights George Sand (*The Snowman*, 1858) and Joyce Kilmer (*Snowman in the Yard*, 1917) as well as modern day classics like *To Kill a Mockingbird* (1960), in which the snowman is instrumental in Harper Lee's illustration of racism in Alabama. Poets Janet Frame (*Snowman Snowman: Fables and Fantasies*, 1963) and Sylvia Plath ("The Snowman on the Moor," 1957) have written prose on the circular figure. Nobel laureate Wisława Szymborska even wrote about the abominable snowman that same year (*Calling Out to Yeti*, 1957). Recently, the snowman was one of the lead characters in Margaret Atwood's bestseller, *Oryx and Crake* (2003). Jo Nesbø's bestselling book *The Snowman* was released in 2007.

"Mr. Reversal of Fortunes," O. Henry, wrote his story with a twist no one could have predicted: A snowman doesn't die in the end—instead, O. Henry dies. The second half of the story was finished by short story writer Harris Merton Lyon when O. Henry realized he was too ill to write anymore. Under the clouds of alcoholism, grave illness and financial ruin, he

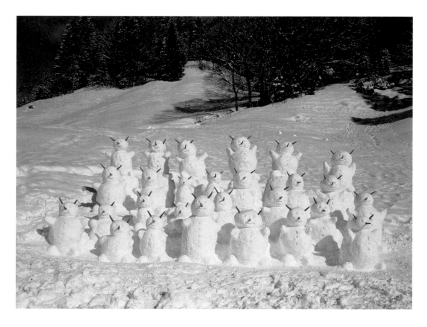

Snowman, *2006, C-Print, 48 x 61 in. Olaf Breuning.*
PHOTO AND PERMISSION COURTESY OF THE ARTIST

*Keith Tyson, artist of this frozen blockhead:*
*"Snowmen are the first way in which children*
*come across the idea of human vanitas and*
*impermanence. We live under the myth that if*
*we produce things, they're going to last. When*
*in fact, everything we make is like a snowman—*
*it's all going to melt in the sun eventually. This*
*sculpture, on the other hand, is built to last. It's*
*made of glass-fibre polycarbonate painted to*
*look like real snow."* © THE ARTIST PHOTO: STEPHEN
WHITE COURTESY OF OF JAY JOPLING/ WHITE CUBE
(LONDON)

*Art performance created by Jasmin*
*Vardimon. Choreographer Jasmin*
*Vardimon.* PHOTO BY ARTIST. SPECIAL
THANKS TO ARTIST, JASMIN VARDIMON

*A well-executed example of snowman making as art.*

told Lyon the details of his last story, "The Snowman" before he died in 1910.

Predictably, the snowman is featured mostly in children's books—most ending the same way, with the snowman melting. And like the snowman's promise to return again each year, every year there are dozens of new releases before the holidays. Illustrated children's books took off when the custom of Christmas gift-giving to children began in 1825. The most popular present was the "gift book."

*The American Boy's Handy Book* (1882), a collection of articles and illustrations by the cofounding father of the Boy Scouts of America Daniel Carter Beard, was the first *For Dummies* book for how to conduct yourself in the schoolyard. Regarding snowball warfare etiquette: "No icy snow-balls are allowed. No honorable boy uses them, and anyone caught in the ungentlemanly act of throwing such 'soakers' should be forever ruled out." In the book are step-by-step illustrations (by Beard, who was also an illustrator for Mark Twain) on building different snowmen, including a snow pig and a Frenchman with a waxed mustache made of two icicles. On New Year's Eve 1860, Hans Christian Andersen wrote a story

*Cartoon by C. J. Hirt, 1905*

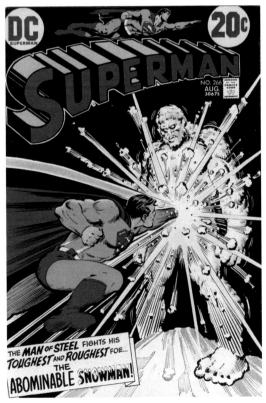

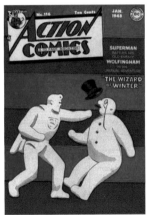

*Just two examples of the snowman appearing in comic art. Superman fighting a snowman, "The Wizard of Winter," in 1948, and in 1973, going up against "The Abominable Snowman."*

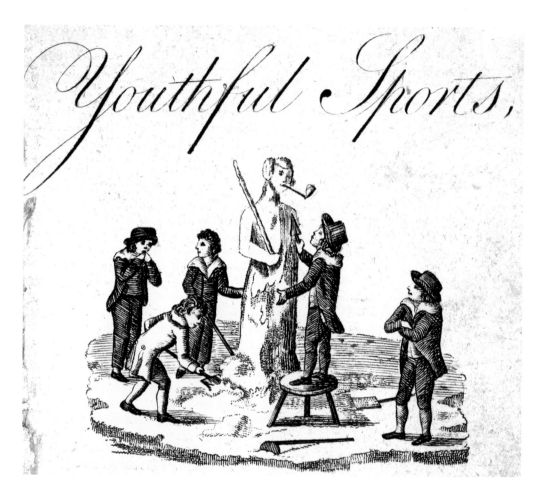

*Youthful Sports (1801). Published in London, this rare illustration of snowman-making is obviously based on an English engraving made twenty years earlier (included in this chapter).*
COURTESY OF COTSEN CHILDREN'S LIBRARY, DEPARTMENT OF RARE BOOKS AND SPECIAL COLLECTIONS, PRINCETON UNIVERSITY LIBRARY.

about a snowman and an old watchdog, who advises his friend, the snowman, not to get involved with a wood-burning stove. Andersen called *Sneemanden* (*The Snowman*) a simple fairy tale, but critics disagree. One scholar feels the last line, "and no one thought about the snowman," is very telling and elevates the story from a child's fairy tale to a metaphor of life, questioning the fate of existence and giving us another example of snowman

deconstructionism. Other scholars push the envelope even further. Is *The Snowman* the first gay snowman? Of course all snowmen are gay; there's nothing gayer than snowmen. But *The Snowman* was a tale of misguided love, about a snowman who falls head over heels for a stove that he mistakes for a woman. It's the usual boy-meets-stove, boy-falls-in-love-with-stove, stove-kills-boy love story. Experts argue that many of Andersen's fairy tales were expressions of his homosexuality, and his protagonists were the victims of unpopular sexual preference. *The Snowman* would be Andersen's best example of paying the price for falling in love with what society then thought of as the wrong type. It's been said that Hans Christian Andersen did not even especially like children and wrote

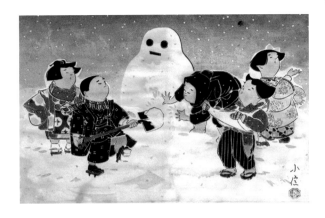

*A Japanese print showing the art of making a yukidharma.*

*Rare netsuke from the 1900s "Boy & Daruma Snowman" by Masahiro. Netsukes are small sculptures that serve as toggles on Japanese robes.* COURTESY OF DMITRY LEVIT ASIAN ART

fairy tales to be in the public eye while using his imagination to disguise himself in his stories. *Strangers: Homosexual Love in the 19th Century*, by Graham Robb, called Andersen an "Aesop of 19th-century homosexuality." The two novels he wrote before his first collection, *Fairy Tales*, contained homoerotic scenes. But no snowmen.

> **❝** The word snowman became official when it first appeared in the *Oxford Dictionary* in 1827, after appearing in a shepherd's calendar. But spotting the words *snowman* or *snow puppets* (what they are called in Europe) in earlier publications is a very rare occurrence. **❞**

Actually, the snowman's first kiss (and the recent merciless exposure of Andersen's frank diary) refutes that theory. It takes place sixteen years earlier, when Andersen wrote *The Snow Queen*, about a northern *femme fatale* made of ice—a parody of and retort to Swedish singer Jenny Lind, the object of his affections who wouldn't give him the time of day. *The Snow Queen*, in a nutshell, is about man's lifelong quest for validation by women and the pain of unreciprocated love.

In any case, the snowman had better luck than Andersen and was on a roll after *The Snow Queen*. He would get another kiss in Nathaniel Hawthorne's *The Snow-Image: A Childish Miracle*, written in 1852 about a little girl who makes a sister out of snow, who comes to life after a kiss by the girl. The family then invites the new member of the family into the living room, where they accidentally melt her in front of the fireplace. *The Snow-Image* was one of the earliest snowman stories in print. Mention of snowmen in fairy tales or children's books before *The Snow-Image* is just in passing.

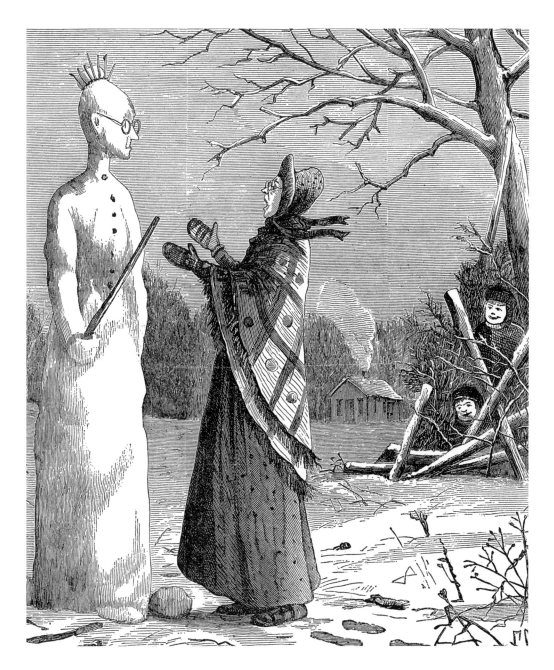

*Titled "Recognition." One of the first times the snowman was widely published. Originally appeared in* Harper's Weekly, 1874.

# THE BIRTH OF A MEDIA STAR

*Festive Austrian New Year's postcard, 1919.*

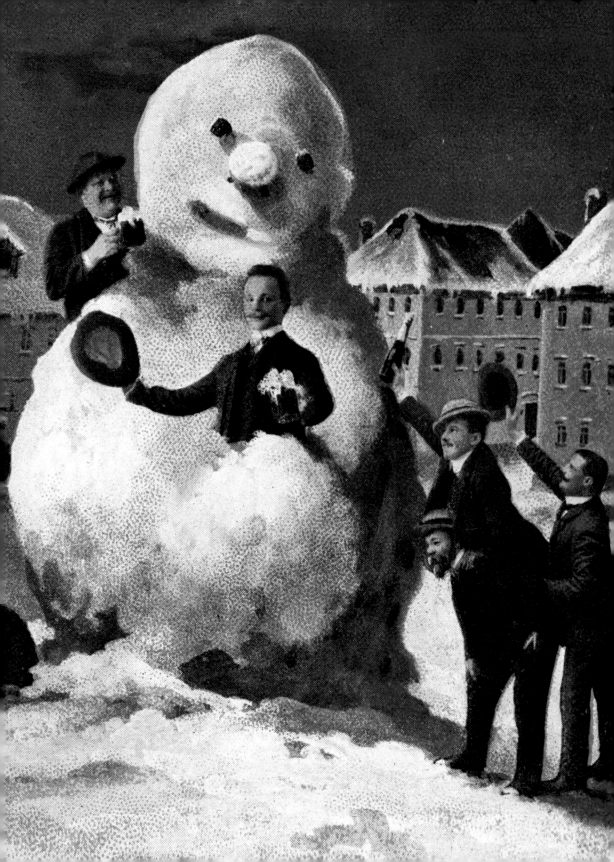

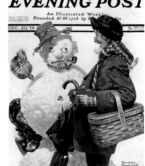

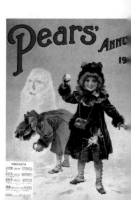

Magazines and cards made stars before movies, television, or radio, and they are credited with transforming the snowman into a household name. Printed cards forever changed our society. They were the first medium to show up *inside* people's homes, an exciting way to reach people, and, along with magazines and newspapers, a way to make anyone or thing a sensation. The postcard could make stars, like Cupid and gnomes. Before this the only publicity machine would have been town criers and medicine shows from the back of a Gypsy caravan—a PR nightmare.

Since the magazine's inception, the snowman has landed as many covers as just about anyone. While other celebrities come and go, the snowman has the advantage of never aging, and as

*Norman Rockwell has painted the snowman for the cover of the* Saturday Evening Post *twice. In 1907 the snowman appeared on the cover of* Pears.

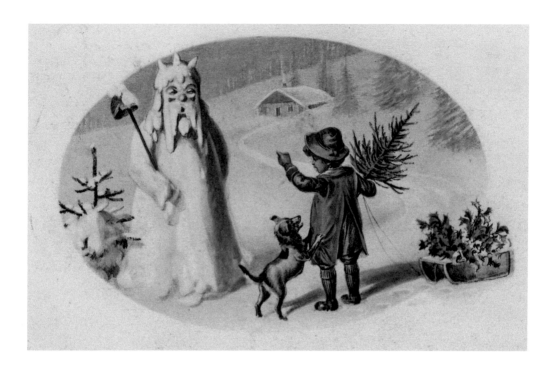

*The snowman appeared from 1907 to 1911 as a realistic person many refer to as Father Winter before he rounded out his look again.*

*Painting from a children's instructional book.*
FIRST BOOK, PUBLISHED BY AMERICAN BOOK COMPANY, 1899

they say in publishing, he's an "evergreen," always hot. Today there are even snowman craft magazines specializing in turning your home into a snowman winter wonderland for the holidays.

Earlier magazine appearances include a full-page illustration in 1874 and his first ever gig as a political cartoon in 1868—both in *Harper's*. Meanwhile, printed cards were circulating everywhere in one of three forms: trade, greeting, and postcards.

Trade cards were free illustrated advertising cards left on store counters. Greeting cards replaced sending letters for the holidays. Postcards came last and were largest of this group, and the most responsible for the beginning of a new American icon: the snowman. Back then, it sometimes took only two or three

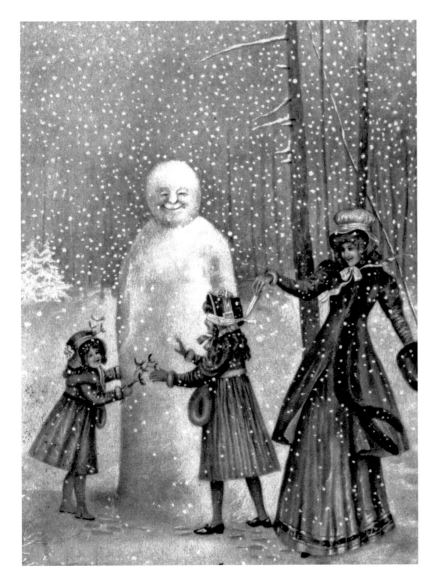

*Beautiful postcard from Belgium, ca. 1910.*

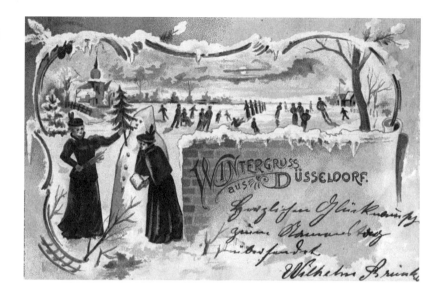

*German postcard, 1898.*

hours for a postcard to be delivered, and it was much cheaper than sending regular mail. Next to yelling out the window, it was simply the most popular way people communicated. Everyone relied on the postcard for much of their correspondence, and

*Unusual and exceptionally early trade card advertising for Crowe's Suit and Cloak Establishment.*

**LEFT:** *Snowman version of Edvard Munch's* The Scream.

**RIGHT:** *1911 postcard.*

in its heyday between 1900 and 1914, a time before television or radio, it became a powerful political and cultural tool as well. The door was open and opportunity knocked. Postcards needed illustrations that made you laugh and cry and provoked thought. Snowmen were a blank slate of emotions and easy to illustrate.

The oldest and rarest of cards are trade cards, which are similar to business cards but beautifully illustrated. During the Victorian era, it was an enormously celebrated pastime to collect these small cards and glue them into a scrapbook. It's here you find the oldest examples of the snowman as a pitchman. As they say, snow sells.

CHAPTER EIGHT

# THE SNOWMAN GOES TO WAR

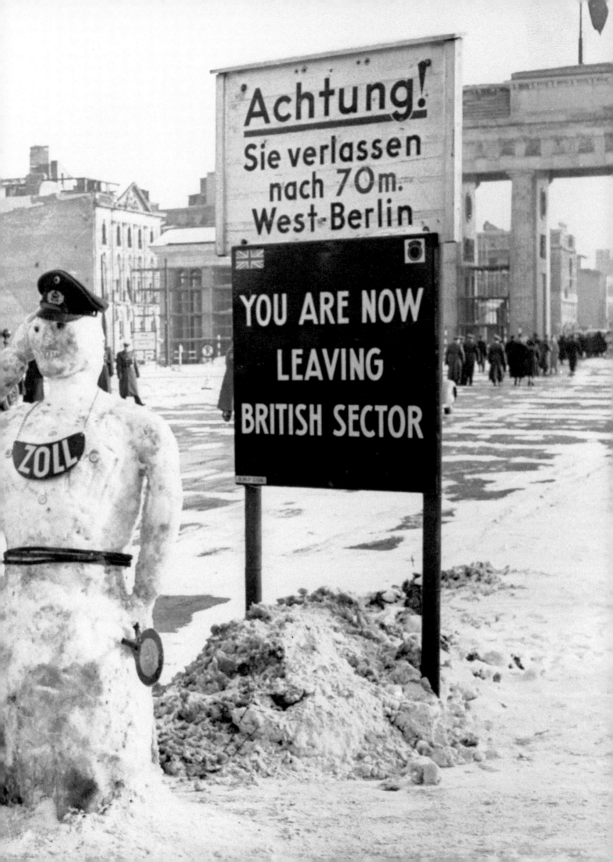

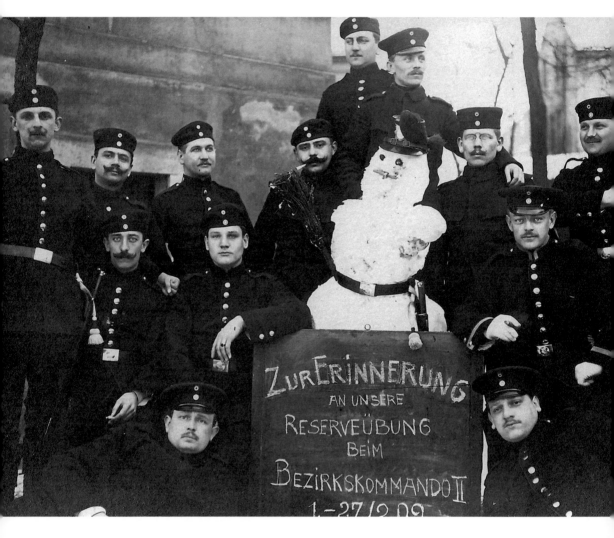

"To the memory of our reserves in the district commando." German soldiers, 1909.

**PREVIOUS SPREAD:** *Soviet Red Army marching into West Germany, 1958.*
COURTESY OF BETTMANN/CORBIS

The snowman has fought in almost every war in which there were troops and snow on the ground. When the United States went to war for the first time in nearly two decades on January 16, 1991, there was widespread support and excitement across the country. Patriots altered holiday decorations: In Massachusetts, a snowman sported Marine fatigues, and in Bowling Green, Ohio, a snowman got to drive a snow-tank.

Based on the following photos and illustrations it is obvious the snowman was in charge of morale.

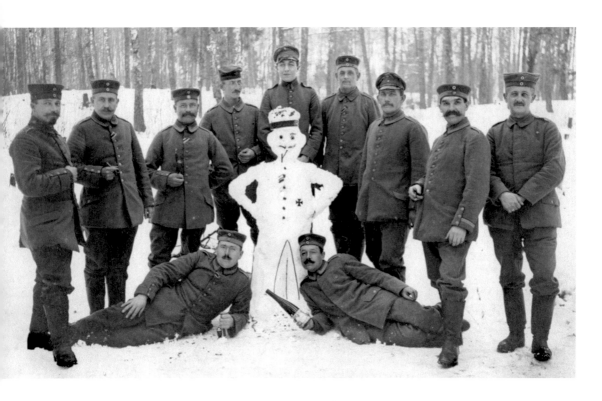

*WWI German soldiers elect a snowman as their leader. 1910.*

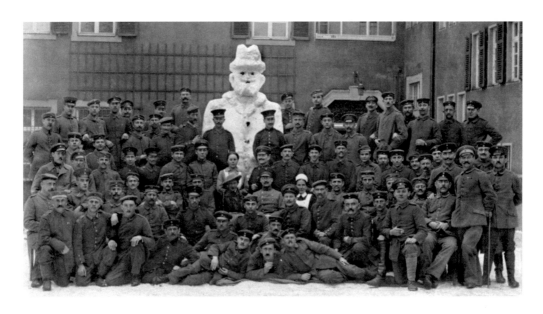

*It's clear who the leader is in this group shot of WWI German soldiers. 1916.*

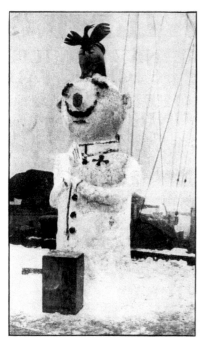

A VERY RAPID THAW.
SUDDEN MELTING OF THE DEMOCRATIC SNOW MAN.

**FAR LEFT:** *"The Kaiser in the Snow," made by British naval officers, appeared in* The Graphic *(August 3, 1918).*

**LEFT:** *The first published political cartoon with a snowman. "A Very Rapid Thaw; Sudden Melting of the Democratic Snow Man."* Harper's Weekly, *1868.*

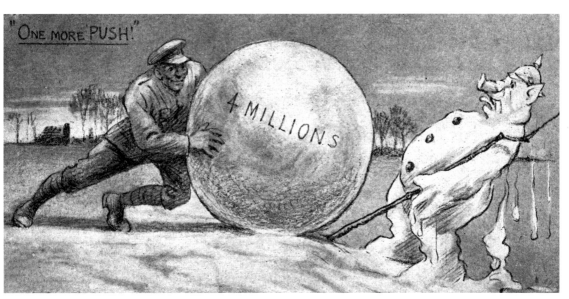

*While the politically charged snowman was doing photo ops, he was also a staple in political cartoons. This one was a greeting card from 1915 and read; "Best Wishes for the New Year from the 11th Corps."*

WWI Christmas card.

Herxlichen Glückwunsch xum Jahreswechsel

WWI postcard, 1914.

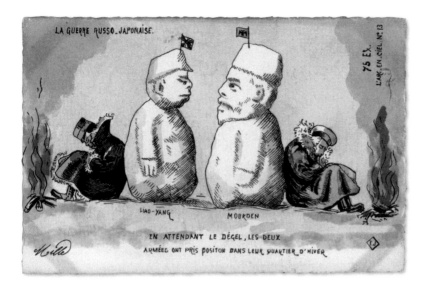

**LEFT:** *Postcard about the Russo–Japanese War, ca. 1904.*

**BELOW:** *"The Three Drips" was the title of this cartoon by Walt Ditzen. Originally appeared as an ad for Philco Corporation in* LIFE, *1943.*

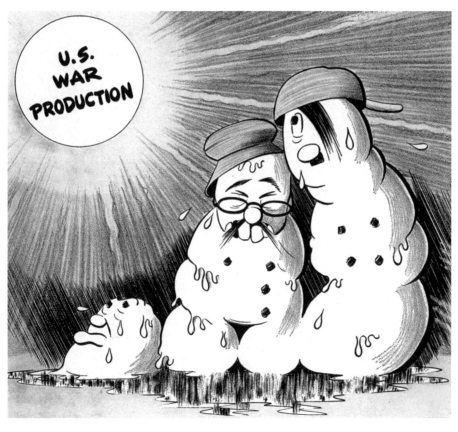

# THE FIRST SNOWMAN SELFIES

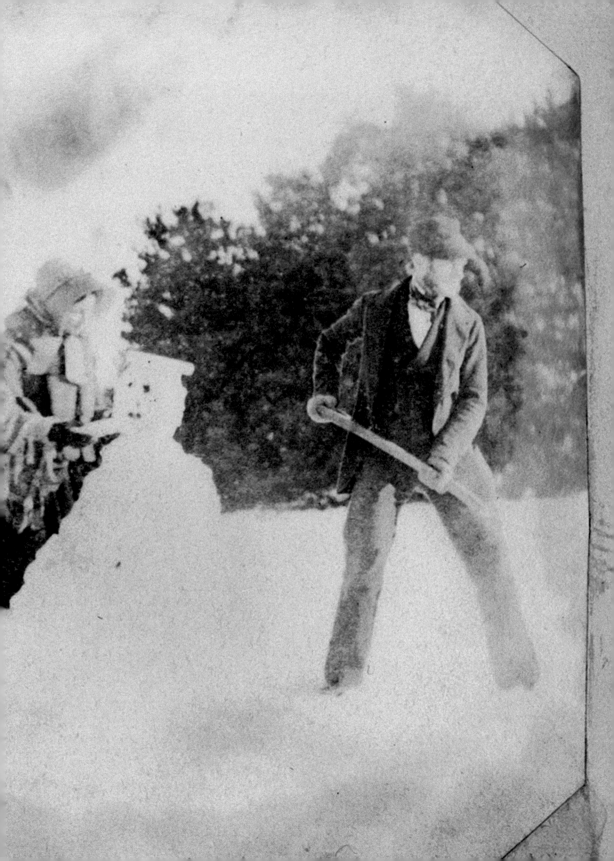

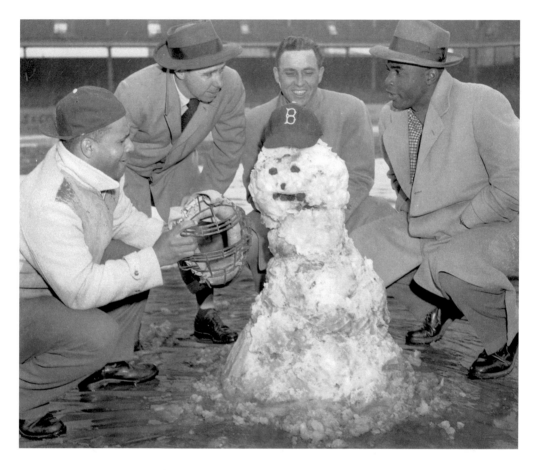

*From left: Roy Campanella, Capt. Pee Wee Reese, a snowman, Gil Hodges, and Jackie Robinson of the Brooklyn Dodgers on the pitcher's mound at Ebbets Field, 1950.*
COURTESY OF BETTMANN/CORBIS

**PREVIOUS SPREAD:** *The very first photograph of a snowman, by photography pioneer Mary Dillwyn (ca. 1845).*
BY PERMISSION OF LLYFRGELL GENEDLAETHOL CYMRU/
THE NATIONAL LIBRARY OF WALES

The snowman has always had a Forrest Gumpian knack of being at the right place at the right time, becoming a staple of mass culture. Whenever the media wants a sound bite, whenever a politician needs a boost in the polls, it's often the snowman left holding the ball.

During the civil rights movement in the Mississippi Delta, the snowman was left outside as spokesman for the militant Freedom Labor Union and Ministry in a protest against President Johnson. The president learned in a telegram that the members of the labor union had locked themselves in the more than three hundred government buildings and left only a spokesperson made out of snow outside. At the entrance of the occupied air force base, the snowman held a sign: "This is our home."

In 1984 Lithuania, as a sign of protest, 141 snowmen were made outside Parliament—one for each member. In that northern European country, the snowman is slang for "a man without brains."

After the first snowfall in the twenty-first century, a Chinese policeman in politically sensitive Tiananmen Square flattened a nonplussed snowman holding the Chinese flag.

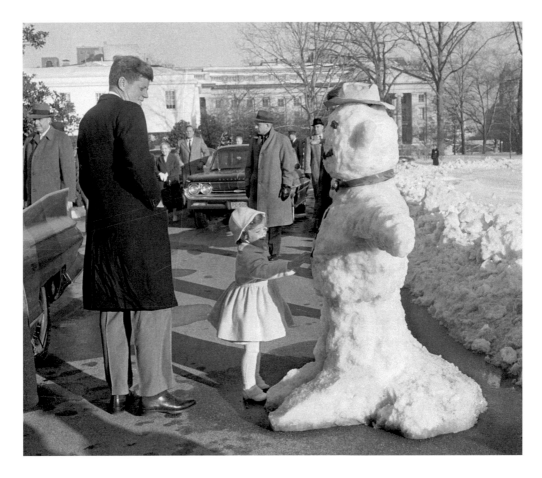

*Pres. John F. Kennedy and daughter Caroline exchange pleasantries with a snowman.*

In 2015 Mohammed Saleh al-Munajjid, a Saudi scholar, decreed that building snowmen, or any living creature out of snow, was anti-Islamic.

Sponsored by the nation's second-largest supplier of green electricity, ENTEGA, 750 snowmen were built by 2,500 humans as a 2010 global warming demonstration in Berlin. The event included readings and discussions about climate change by protesters.

The snowman found himself right in front of the camera lens even at the birth of photography in the 1840s—yet another example of the snowman's uncanny ability for being present for man's most important advancements.

In Swansea, Wales, a young woman named Mary Dillwyn made a little photo album as a gift for her disabled niece. This collection of forty-two salt prints came back to Mary when her niece passed away at age twenty-four. The photo album stayed in the Dillwyn family for over 100 years. It went on public display for the first time in 2002, when the National Library at Aberystwyth purchased the small collection for $77,344.

Mary Dillwyn was one of the pioneers of photography, and her rare album was likely the first of its kind to use photography as an art form, including what is probably the earliest photo of a person smiling. Early cameras required the sitter to remain motionless for minutes at a time, enough to tire

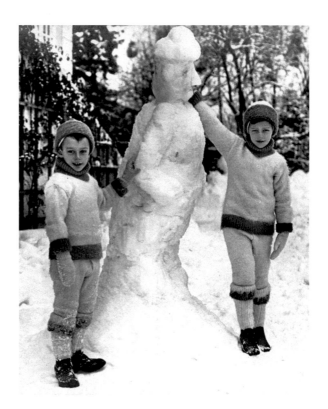

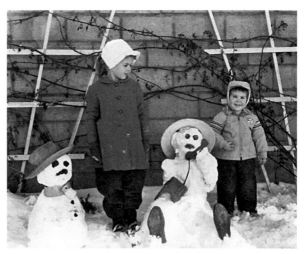

**TOP:** *Prince Wilhelm and Prince Louis Ferdinand of Prussia (1913).*

**BOTTOM:** *Kansas, ca. 1970s.* COURTESY OF GRAY JUSTIS

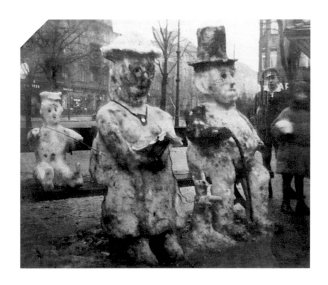

*1931 photograph.*

most people's facial muscles. Combined with bad teeth and social customs that frowned on being candid, the first photographs often depict subjects with serious expressions.

Mary, however, had one of the first small cameras with short exposure, enabling her to document such fleeting moments as a child's smile, a fast-moving chicken, or spontaneous family moments. Mary's collection includes two

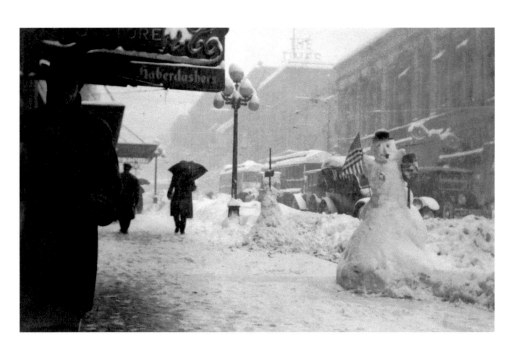

*Seattle's greatest snowstorm, 21.5 in., Feb 2, 1916. Exhilarated snowman celebrating.* COURTESY OF PAUL DORPAT, PAULDORMAT.COM

**TOP:** *Giant snowman getting behind a family.*

**BOTTOM:** *Very early photograph of a family having fun in the snow with their snowman (ca. 1880).*

*Victorian lady in an early selfie showing off the sexy legs of her bowlegged snowman.*

startlingly powerful images of a snowman. No one had ever seen this on film before. Following her marriage to a reverend in 1857, and because of her distaste at photography's increasing commercialism, Mary never took another photo of a snowman again

and gave up photography forever. Any two-dimensional artwork of a snowman before this time is not only either a drawing or a painting, it is extremely rare.

*Photograph from 1902.*

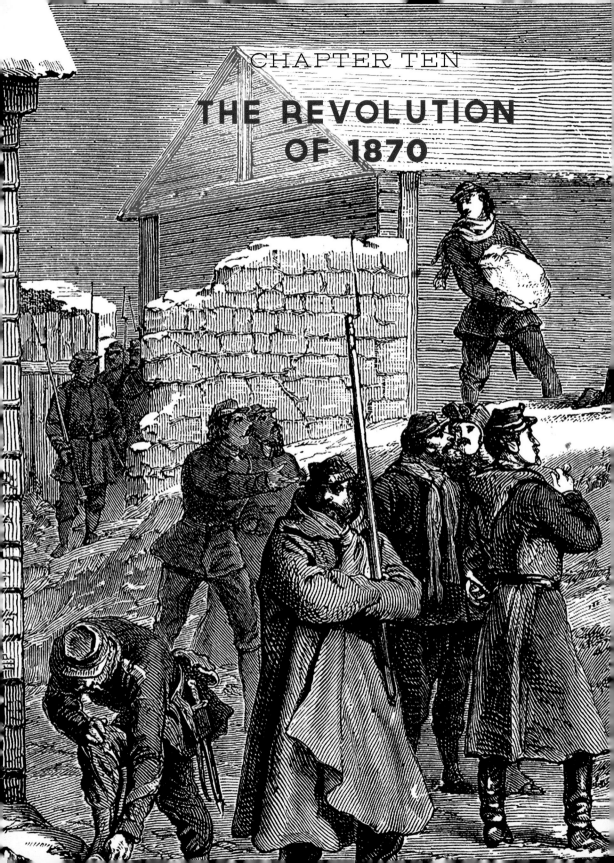

# CHAPTER TEN

# THE REVOLUTION OF 1870

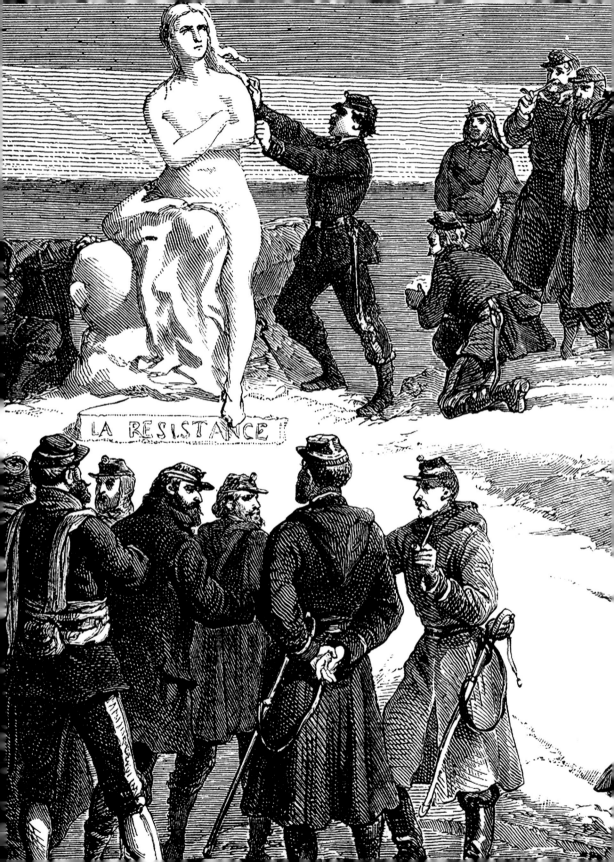

LA RESISTANCE

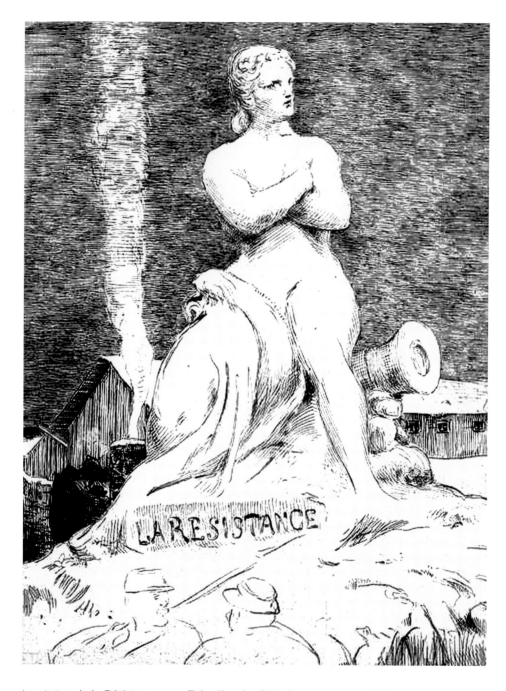

La statue de la Résistance, par Falguière *by Félix Bracquemond, 1870.*

Late nineteenth-century Paris, the fashion capital of the world, predictably hosted the best-dressed snowmen in the world. When noted prude Madame de La Bresse passed away in 1876, she instructed in her will that all 125,000 francs (about $22,500 today) of her fortune was to be spent only on putting clothes on the vulgar and offensive naked snowmen in the Parisian streets. This bizarre bequest may have had something to do with a certain celebrated snow statue made during the latter part of her life, in 1870.

What started out as a group of soldiers taking a break on the battlefield would come to be known as the *Musée de Neige at Bistion 84* (The Museum of Snow). The centerpiece was a colossal snow sculpture called *La Résistance*, the most important snowman ever made. This provocative snow sculpture became a powerful piece of art with far-reaching artistic and political influences, a historical event in its own right.

The Seventh Company of the Nineteenth Battalion of the French National Guard, stationed at the southern edge of Paris during the Prussian attack in December 1870, was a who's who of French pop culture: artists Alexandre Falguière (renowned sculptor of *Joan of Arc*), Hippolyte Moulin (famous for his sculpture *A Lucky Find at Pompeii*), Henri-Michel-Antoine Chapu (painter of *Jeanne d'Arc*), Eugéne Delaplanche (along with Falguiére, part of a group of artists called *Les Florentins*), and Auguste Lepére (the world famous engraver). Also in this troop were musician M. Leneveu, engraver Desmadryl, and painters M. M. Chenavard, Francais, Carolus Duran, Toulmouche, Lansyer, Lambert, E. Oudinot, and Ranvier.

The date was December 8, 1870. Snow began to cover Paris. Bored officers threw snowballs, and some of the artists began to make snow sculptures. One soldier, Alexandre Falguière, channeled his angst of his home city being attacked by creating *La Résistance*, a colossal snow-woman, which was constructed in a mere two to three hours with the help of others.

Although the artist Moulin built a huge bust of a head of the same woman nearby, it was twenty-nine-year-old Falguière's snow-woman that attracted the press to the site. Beautiful in its own right, it also captured a moment of pride and angst, and became a rallying cry for a turbulent time in France. It was groundbreaking, not just because Falguière used snow, but because he allowed a female nude to represent the concept of *La Résistance* abstractly. The new symbol was quickly reproduced in *L'Illustration* magazine. Accompanying the illustration was a flattering essay by critic Théophile Gautier, who made a special trip, like many others, to see the *Musée de Neige*.

During this particular era, artists rarely created nudes, even indoors. This was a defiant gesture, marrying a political statement with the female form—one that was both nude and totally brazen.

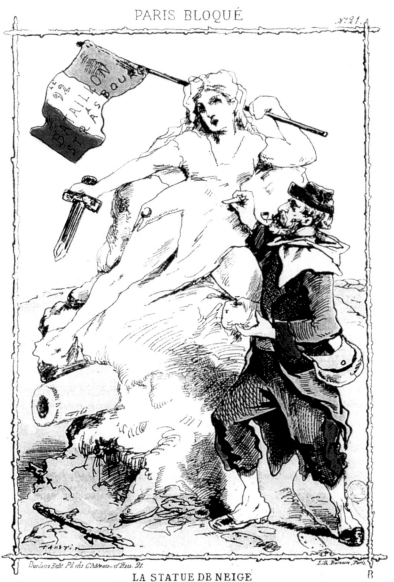

**LA STATUE DE NEIGE**

Un Souvenir du mois de Décembre au bastion 75.

Drawing by Félix Philippoteaux, published in the
December 31, 1870 issue of L'Illustration.

Although Falguière was already a star at the Salon when he made *Résistance*, it was a crucial moment for him. The snow sculpture was Falguière's very first female nude, a subject he would become known for—and stay fixated on the rest of his career.

The artist Félix Philippoteaux, who belonged to the same company, made a sketch of the snow-woman at the time. Later many artists would re-create Falguière's snow-woman using all sorts of different materials besides snow. English wood-engraver Burn Smeeton, who worked in Paris, rendered an engraving based on the Philippoteaux sketch, which was published days later on New Year's Eve, 1870, in the art magazine *L'Illustration*. Gautier's pupil Théodore de Banville published a poem about the snow figure. Félix Bracquemond, a printmaker who led the 19th century revival in French printmaking, made an etching as well, which the caricaturist Faustin included in *Paris Bloqué*, a series of lithographs.

According to Gautier, Falguière himself had promised to make a copy of his snow figure—to conserve its expression and movement—as soon as he finished serving his term in the *Garde nationale*. But in June 1872, at the first Salon show since the war, critics were disappointed to see the sculpture had still not been "solidified in plaster or marble." It would never appear at the Salon. Critic H. Galli wrote in 1895:

*As soon as Falguière was back in his studio, he took up his modeling knife, but he sought, worked, and suffered in vain. None of his maquettes had the proud allure, the poetry of his snow statue; he destroyed them. The capitulation, the dismemberment of France, and then the awful civil war had, alas, dissipated his last hopes. The inspiration was dead.*

**" None of his maquettes had the proud allure, the poetry of his snow statue; he destroyed them. "**

Recapturing that magic would prove to be impossible for the unflagging Falguière. Eventually he created many variations in wax, plaster, terra-cotta, and bronze, ranging in size from two to four feet high, all less successful than the original snow sculpture. Falguière could never duplicate the spontaneity and urgency one can achieve when making a snow-woman near the front line, surrounded by a troop of men. That moment had melted.

# CHAPTER ELEVEN

# THE SNOW ANGEL OF 1856

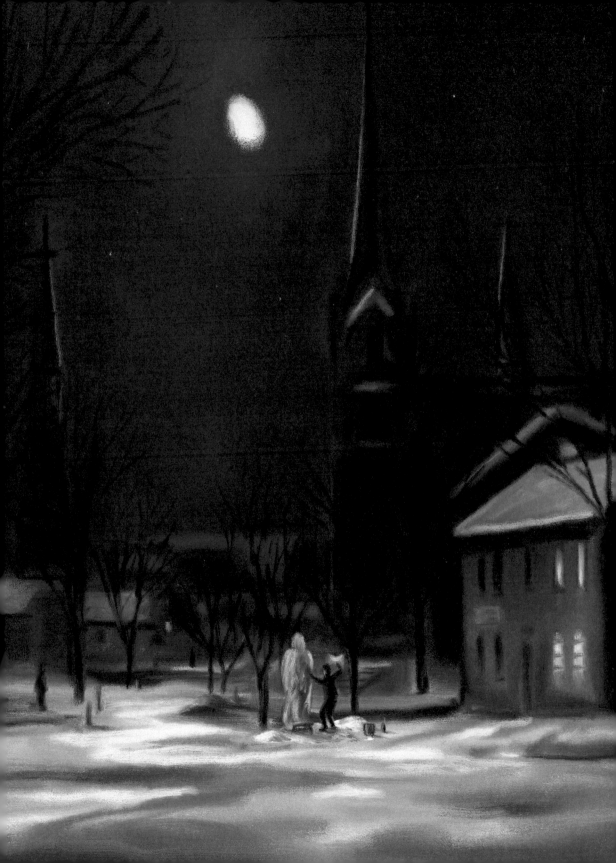

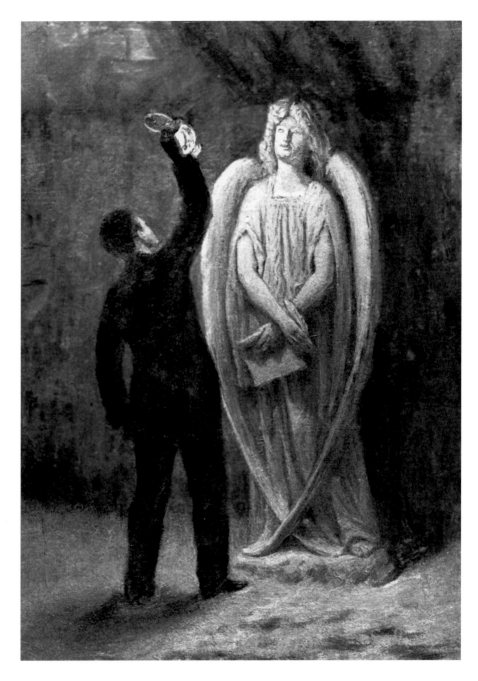

*From* Picturesque Brattleboro *by Rev. Frank T. Pomeroy, editor, 1894.*
COURTESY OF CHRISTOPHER GROTKE, CO-FOUNDER, IBRATTLEBORO.COM

**N**ever before had the decision to go out and make a snowman changed one man's life so dramatically. On New Year's Eve of 1856, in Brattle-boro, Vermont, a young Larkin Mead made a snow sculpture that by the next morning would launch the career of one of America's most important sculptors and propel him into world fame.

His snow-woman was affectionately called *The Snow Angel*. The concept of the piece, appropriately enough, was to make a "recording angel," the mythical figure with a pen and tablet who keeps track of the year's events at the close of each year. He was helped by two brothers, employees of his at the drawing school he had opened on the same corner. It was they, Edward and Henry Burham, who convinced Larkin Mead to try his hands at this undertaking. Working with snow, Larkin and Edward molded the figure by hand (not with ice chisels) and formed the features with the help of water. Henry helped by providing a constant flow of alcohol from a neighboring foundry, where the snowman makers took occasional breaks from the bitter cold,

sitting next to a fire drinking sweet cider. The three worked till dawn.

Waiting at dawn for the town of Brattleboro was a master-piece. The town's reaction was reported by the *Vermont Phoenix* newspaper:

> *The inhabitants of the village discovered 'The Snow Angel,' in the prismatic glow of the morning sun's reflection. The early risers and pedestrians about town were amazed, when they drew near, to see what appeared at a distance like a school-boy's work turned to a statue of such exquisite contour and grace of form. . . . The passing school-boy was awed for once, as he viewed the result of adept handling of the elements with which he was so roughly familiar, and the thought of snowballing so beautiful an object could never have dwelt in his mind. It is related that the village simpleton was frightened and ran away, and one eccentric citizen, who rarely deigned to bow to his fellow men, or women either, lifted his hat in respect after he had gazed a moment upon Mead's work.*

Initially, no one knew who was responsible for the statue, and townspeople credited it as the work of an angel. The curious traveled far to see the spectacle. The event achieved almost instant national recognition, and even the *New York Tribune* covered the story. Eventually, it received notice in publications around the world. Although hundreds of people visited the monument, awe-inspired respect protected it, at least until the usual January thaw. In an early letter (1857) a family friend wrote,

> *Larkin Mead's snow statue is opening the way to a fine career as an artist. Mr. Longworth . . . promises to send*

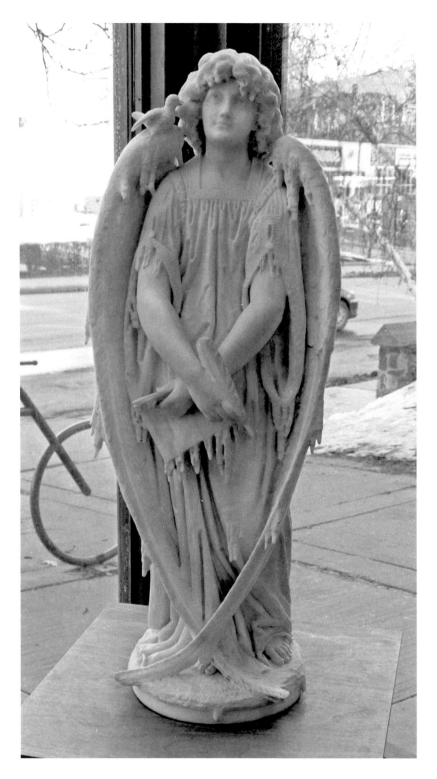

The Snow Angel, *marble replica made in 1886 on display at the Brooks Memorial Library. The year before,* Harper's Weekly *devoted a full page to* The Snow Angel, *complete with illustration and poem.* COURTESY OF SPECIAL COLLECTIONS OF BROOKS MEMORIAL LIBRARY, BRATTLEBORO, VERMONT

*him to Florence. . . . He also has engaged him to execute a full-sized marble statue of the snow work. This is all a secret between the old gentleman and the boy. . . .*

Walking down Main Street today, one can spot the back of a small statue through the front window of the Brooks Memorial Public Library. Once inside this town library the front of the sculpture becomes clear—a beautiful delicate angel, the size of a small child. Made of marble in 1886 by Larkin Mead, it's only

**CAPTION FOR POSTCARD OPPOSITE:** *Made of granite, The Wells Drinking Fountain features two lion head medallions, a large basin, a hanging electric lantern, and iron scrollwork. It was moved once in 1906 to its present location just south of the District Court of Vermont building, twenty feet from the original spot where William Mead's brother made The Snow Angel.*

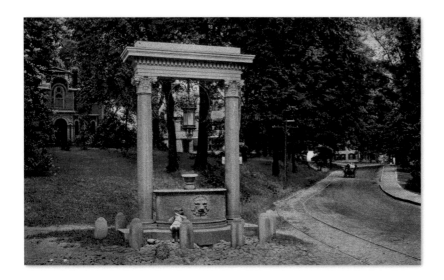

a replica of his great feat made thirty years earlier across the street. In the general area where she stood over one hundred years ago, there is now a monument called The Wells Fountain, designed and constructed in 1890 by Mead's younger brother William. The water fountain commemorates *The Snow Angel*, a clever nod to the long-melted snow-woman.

By the time Larkin Mead died in Florence in 1910, he was world famous. Although he was buried in Italy and spent most his life there, he was best known for his American monuments and memorials. Right before he died, he had returned with his wife by ship to his hometown of Brattleboro. Mead had not been back to America in thirty years. The homecoming was big news for the area, and local papers followed their hometown hero's every step. Townspeople still fondly remembered and talked about *The Snow Angel*. While Mead's most famous and most scrutinized undertaking, the Lincoln Memorial in Springfield, Illinois, took six years to complete, it was the eight-foot-tall snow statue made in one night that is Mead's most beloved piece.

# CHAPTER TWELVE

# THE MASSACRE OF 1690

Schenectady Before the Massacre of 1690

It is very possible that the first snowman in America was connected to one of the bloodiest events in early American history. What exactly transpired one tragic evening in upstate New York, called the *Massacre of 1690*, is still a matter of contention. The details of this event have been rewritten many times in the form of poems, songs, and history books, based mostly on rumor—often to suit the desires of different political sides.

What we do know is this. In February 1690, the villagers of Dutch Schenectady had no idea that hundreds of miles north of them their fate was being decided in Montréal. Traveling nine days in snowshoes in knee-deep slushy snow down the Mohawk Valley, 210 Canadian French soldiers and Algonquin Indians came within sight of the town. The trip was so strenuous that the attackers were prepared to surrender if there was any resistance. It was eleven o'clock at night and a blizzard had kicked in. The initial plan was to attack at two o'clock in the morning, but the war party acted fast, as temperatures were dropping and the north gate was surprisingly open.

This was a town with over 120 residents, most of them children. The streets were filled with shops and surrounded by eighty homes, all confined in a tall stockade fort with two gated entrances. Around 1690, that part of upstate New York would have been one of the furthest outposts from white civilization; settlers lived in constant fear of the unknown. Most of the settlers were Dutch and they hated the English Captain John Sander Glen, who commanded the township. The villagers ignored his advice, leaving their gates open during the snowstorm. Historian Nathaniel Bartlett Sylvester recounts the villagers' disdain "[they] ridiculed him and placed a snow image as mock sentinel. There had been some partying that night . . . before the open gate, its blind and dumb warder [snowmen], stood the French and Indians."

Records indicate that the Douwe Aukes Tavern was the center of most of the ruckus and riots inside Fort Schenectady, and on the night of the massacre this is where the two AWOL guards could be found, drinking instead of guarding the north gate. While they left their post, 114 Frenchmen and 96 Indians waltzed into Fort Schenectady and, in two hours, killed 60 villagers.

Were two snowmen really left to guard the townspeople of early Schenectady? Was this just a portion of the story that storytellers later embellished? One point agreed on is that the gate was stuck open from the snow and that it was wrongly assumed that no human would be traveling under such bad weather, enemy or otherwise. Nobody would have wanted to stand guard—several sources sited high winds—let alone "[stay] outside to make snowmen out of militia defiance," reported one historian. And any snowmen would have been made in daylight before the storm got unbearable.

In another account historian Nathaniel Sylvester wrote that "although the Schenectady burghers knew there was danger of attack, the open gates of the town were guarded only by the snow men the village boys had made at the portals."

There exists no primary source that reveals who made the snowmen, and no French officer wrote of seeing snowmen—it was pitch-black: "The attackers snuck in during the dead of night without [a] torch."

While the snowman portion of this tragedy reeks of finger-pointing and fatal oversight, reasoning would have it that there's a kernel of truth here. Certainly, *someone* made a snow figure. Why else would a storyteller add such a trivializing detail to an otherwise brutal event? No one slanders a person by accusing them of making a snowman, of all things. Almost every historic source corroborates the snowman detail. We'll never know whether this was the first American snowman, but the Schenectady Snowman is definitely the earliest *reference* to one.

*"1690 SCHENECTADY 1990 Schaghnectatie Feb 7, 1690," snow globe.*

# THE MIRACLE OF 1511

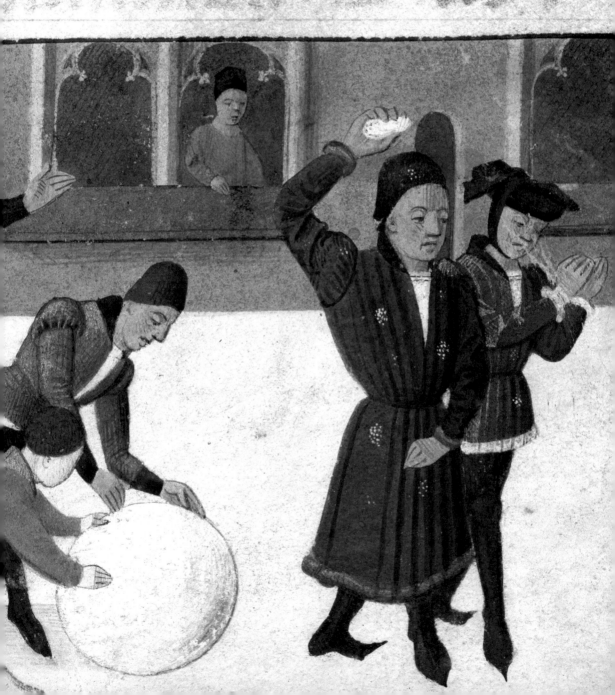

*This competition began in 1895 with prizes for best sculptures. In the year 1905, the subjects included an electric car, a steam engine, and fairy tales like the Pied Piper of Hamelin. New York Tribune, January 22, 1905.*

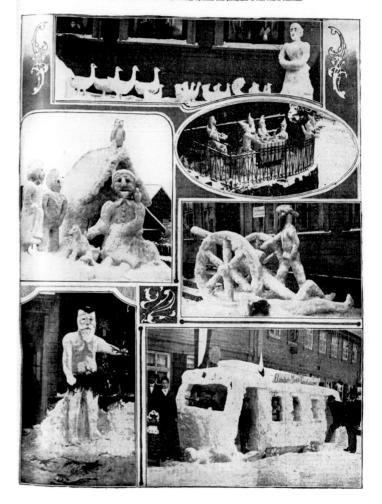

New-York Tribune.

ILLUSTRATED SUPPLEMENT.

SUNDAY, JANUARY 22, 1905.

THE MAKING OF SNOW MEN THREATENS TO BECOME A FINE ART.

Scenes from the annual snow festival at Andreasberg, Germany, reproduced from photographs by Felix Potz, of Duderstadt.

**PREVIOUS SPREAD:** Hours of the Duchess of Burgundy, *ca. 1450, called "December," a father and son make an enormous snowball. Can mean only one thing—a huge snowman.* MS 76/136F. 12V. "DECEMBER: STREET SCENE IN THE SNOW," FROM THE *HOURS OF THE DUCHESS OF BURGUNDY*, CA. 1450 (VELLUM), FRENCH SCHOOL (15TH CENTURY). MUSÉE CONDÉ, CHANTILLY, FRANCE. BRIDGEMAN IMAGES

**U**nlike anything else we see in history, the snowman becomes *more* advanced as we go back in time. Many were created by artists striving toward making works of art; as a result, snowman-makers put considerable time and effort into the craftsmanship of snowmanship. The sculptures made at snow festivals, like the one pictured on this page from 1905 in Andreasberg, Germany, were considered fine art.

What really defines these snowmen are that they are conceptual. "Renaissance Snowmen" built with a purpose: to make a statement. There was a tradition among artists of populating the city with snowmen when it snowed. Consequently, these snowmen were more important than today's and often played a significant or leading role in a historical event, like the snow-woman of the Revolution of 1870.

Even Michelangelo dabbled in what we would today consider the pedestrian activity of snowman-making. It didn't snow often in Florence, but in 1494, after a heavy snowfall on January 20,

Piero de' Medici, who had inherited control of Florence, commissioned the young sculptor to model a colossal snowman in the courtyard of his palace for part of the evening's winter festival. Michelangelo felt indebted to Medici's father, an old friend and loyal patron of his work. Unfortunately, not much was documented about this snow project. Old biographies (e.g., Giorgio Vasari's *The Lives of the Most Excellent Painters, Sculptors and Architects*, 1550) verify the happening, but shed no light on the subject of the snowman.

The critic Théophile Gautier, when writing about Falguière's snow-woman in Paris in 1870, mentioned Michelangelo's snow statue, stating: "It is not the first time that great artists deign to sculpt this Carrara marble that descends from the sky onto the earth in sparkling powder."

Seven years later in 1501 Michelangelo would begin *David*, the world's most famous statue and complete it in 1504. But seven years after that something immensely more momentous occurred in the world of sculpture. A bunch of Belgians covered their town of snowmen in the Miracle of 1511.

Not only did snowman-making exist in the Middle Ages, it flourished. In a time when stilts and puppet shows would pass for entertainment, the public was starving for the next "big thing." With plenty of famine, plague, and sickness abounding, winter festivals and other government-endorsed morale boosters provided relief to the starving masses, who were either feeding on grass or dropping dead. The thinking was to have the public blow off steam for a week or two and allow erotic dancing, excessive drinking, and political jokes, all under government supervision. So during the brutal winter in 1511, the city of Brussels filled their streets with snowmen.

For six straight weeks beginning on January 1, the temperatures stayed below freezing, and these snow sculptures represented the public's fears and frustrations during what was called The Winter of Death. The winter festival would be a

*Engraving by Ludwig Richter, 1858.*

much-needed distraction from the cold, the class strife, and, of course, the Guelders. The Guelders were from Gelderland, once a part of the Low Countries in the Netherlands, and they enjoyed attacking the town of Brussels.

From the colorful surviving accounts, we know that these were not your run-of-the-mill snowmen. Every corner of Brussels was occupied with snow men and women pantomiming the local news or classical folklore: snow biblical figures, snow sea knights, snow unicorns, snow wild men, snow mermaids, and snow village idiots. Some snowmen were based on the icons of the calendar, like Janus (January) and Pluto (February) or the signs of the Zodiac. Snowmen were juxtaposed with neighboring snowmen to create clever interplay and contrast. A snow scene of Christ with the Woman of Samaria was on display. Other scenes included a preaching friar with a dripping nose, a tooth-puller (a Medieval

barber-surgeon-performance artist), the "Man in the Moon," Roland blowing his horn, Cupid with a drawn bow atop a pillar, St. George rescuing the princess from a dragon, and Adam and Eve.

A snow Hercules stood outside the home of Philip of Burgundy, son of Philip the Good and commander-in-chief of the Netherlands. The miraculously beautiful, perfect proportions suggest Philip was helped by the court painter Jan Gossaert van Mabuse, a leader in Italian architecture and Renaissance art who had just rendered several nude paintings of the Greek hero for Philip. Everyone, even great noblemen, went outside to make quality snowmen, not just trained artists. There were fifty elaborately executed scenes with a total population of 110 snowmen. Also on display were politically charged and sexually obscene snow scenes in the streets for all to see—an early form of visual satire and social commentary. Current events, complaints, local problems—if it was a nuisance, it was sculpted. Snow gentlemen gambled near the *Houtmarkt* (the wood market). Nearby stood a peeing fountain boy, who would go on to become the symbol of the city of Brussels, *Manneken Pis*. A snow cow fertilized the ground.

The Miracle of 1511 was an open forum to create erotic snowmen, stirring things in the nether regions. This was their Woodstock. More than half the scenes were scatological or sexual in nature with numerous snowmen sculpted in erotic embrace. A snow man and woman made love in front of the town fountain. In the red light district of Brussels, a snow hooker attracted every passerby. In another scene, a snow nun seduced a man.

Politically, the role of the snowman was never more integral to the Brussels community. The display of frozen politicians was the town's de facto op-ed page. Townspeople depicted the most feared characters, like the devil or an enemy ruler from the rival castle of Poederijen, in uncompromising poses. A sculpture of the King of Friesland (Freeze-Land) represented Satan, who was

responsible for winter and blamed for deep frosts and the serious
annual threat it brought to everyone's health and earnings.

Historians have traditionally ignored the event of 1511 because,
besides the artwork's transience, it was considered low art; these
snow men and women were embarrassing examples of the pub-
lic's taste, but this was the norm for 1511. Exactly 476 years would
pass before the general public would see an anatomically correct
snowman (in Woody Allen's movie, *Radio Days*).

History has long since forgotten the Brussels snowmen of the
Miracle of 1511, along with the ballad that describes the event by
the official town poet Jan Smekens: "Dwonder van claren ijse

**Ik ben de sneeuwman, goob, goob j'goob**

en snee: een verloren en teruggevonden gedicht" ("The Miracle of Real or Imaginary Ice and Snow: A Lost and Then Refound Poem"). While a shorter title could've helped, it was the ballad's status as "low art" that has left it neglected all these centuries. Despite a reprint published in 1946, literary historians still

considered it a product of the lower class, both amateur in style and written in a vulgar, common tongue instead of Latin or French.

How do we know that the snow festival wasn't the Dutch poet's imagination? There are short accounts in diaries that confirm the Miracle of 1511 ("Many beautiful, splendid and surprising images of snow, placed all over town"). These sources also support the claims of the snow figures being both political and sexual. Change did come as a result, and the voices of the townsfolk were heard.

The Miracle of 1511 was not the first snow festival, nor was it the first with snowmen. There was one of a smaller scale in 1481, and other nearby cities hosted similar events: Mechelen, Belgium (1571), Rijssel, France (1600 and 1603), and Antwerp, Belgium (throughout the seventeenth and eighteenth centuries). But the Miracle of 1511 was the festival to top all festivals. It changed the society of Brussels, by giving the public a voice, resulting in government change, shifting the balance of power back to the public, and changing the class system within Brussels forever. This was the snowman's defining moment; it demonstrated what snowman-making can be about. Snowmen provoked thought, anger, joy, and even forced people to reassess their existence, their plight, their place in the world. These snowmen were the rock stars of their day.

The Miracle of 1511 proved that snowman-making was not just for great artists—it was an art for and by the people. The citizens of Brussels not only covered their city with art—everybody became an artist. In recent history, there was a fad of American cities adorning the streets with painted cows (and recently the first European city, Florence, joined in on the bovine fun), but the cities commissioned cows by professional artists. Nobody in Brussels had to audition to build a snowman.

Sadly, this story ends as every snowman story does: A sudden thaw in the spring melted all the snowmen, and Brussels suffering devastating floods.

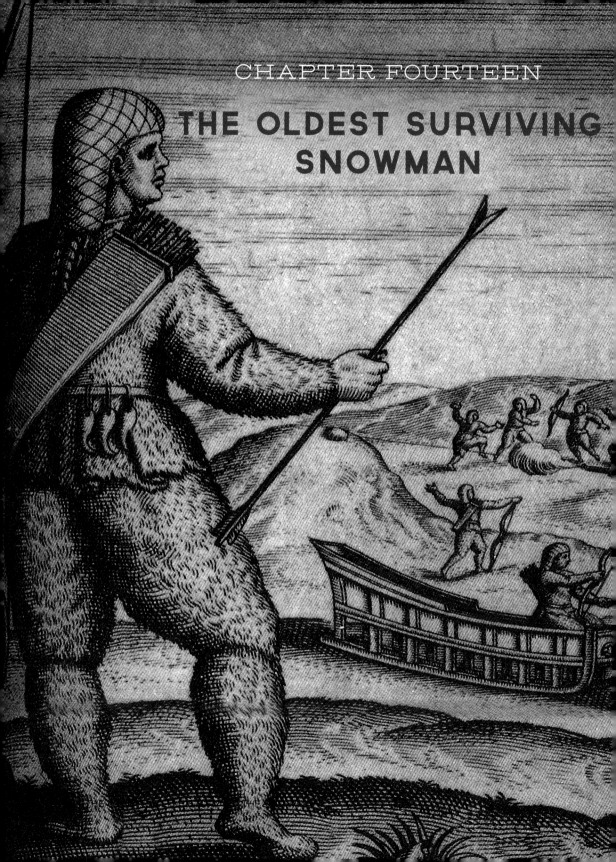

# THE OLDEST SURVIVING SNOWMAN

od heere hets recht dat ic v groete
ant ghi sijt mijn toeuerlaet.

c gruetu pot ende spongie mede
S gode dunke met was gegeuen
G alle edie groet bitshede
H atmen hem dunke soet es besciue
H eere cort d na lietty v leuen
S oen ghi spraect hets al voldaen
S oe ghi de bittere dranc hadt beleuen
S oe gheeft mi lije in duegde te uolstac.

Snowmen were a huge phenomenon in the Middle Ages. As soon as kneadable snow arrived, towns filled with snowmen and snow sculptures comparable in quality and concept to their stone and bronze counterparts. Lucas Landucci, a pharmacist of a Florentine apothecary, wrote in his diary in 1510, "A number of the most beautiful snow-lions were made in Florence . . . and many nude figures were made also by good masters."

A famous ballad written in 1461 by the great French poet François Villon asks, "But where are the snow (figures) of yester-year?" This was not referring to the prison Villon was writing from but to the snowmen of past winters, specifically, the gloriously creative explosions of Brussels (1457) and Arras, France (1434)—with their beautiful biblical representations, mythological stories, and medieval heroes.

It was in Arras that snowmen were born from an exceptionally harsh winter, when it snowed for three months and three weeks

starting on November 30, 1434. The Arrageois handled this by laughing in winter's face and throwing together an unplanned *fête*, with death as the party theme. The *Danse Macabre* (Dance of Death), occupied all facets of life. In the past, winter *fêtes* would send the dangers of frost packing through dance, fire, and smorgasbords, but historians record that the town of Arras produced spectacular snowmen. Although smaller in scale than the snowmen of the Miracle of 1511, they combined pop reference with learned culture, producing a sophisticated collection through the medium of snow. Placed in the proximity of their targets, the snowmen were arrows of anticlericalism and impertinence toward the king. On the rue de Molinel, the great Lord of Short-Life stood, made of snow, next to his tomb. A snow preacher named Brother Worthless held court at the corner of rue de Haizerrue, representing hope, desire, and patience. Before the Inn of the Dragon stood the "Great Virgin" Joan of Arc, who passed through Arras three years earlier in 1431 before she burned at the stake. At the Ernestal, a large woman named Pass-on-Your-Way stood. Other characters made in snow represented Renard the Fox, Samson the Strong, lepers, the emperor, the king, Death, and a workman, conveying equality in death. The Four Sons of Aymon steam bath was decorated with snow men and women (as with other locations picked to make snowmen, this steam bath was a site of debauchery). If Brussels was the peak of snowman popularity, then Arras was the snowman's intellectual apex.

People traveled from far away to take walking tours through the streets of Europe when snow fell, as popular a form of entertainment as it was insulting to certain groups.

Each social class in the Middle Ages (the elite, the middle class, and the lower class) created their own brand of snowmen

caricaturing their opponents, causing heated animosity. Offended parties acted out by beating up the snowmen hurtful to them. Chronicles of the day reported the violence: "St. Joris lost his head, the farmer Bouwen Lanctant lost his 3 times. . . ." This was not random vandalism but a reflection of class tension. One farmer put a large rock in the head of a shepherd snowman he made, knowing that at night there would be those to take a club to it. In Brussels, authorities decided to take action, and posted flyers threatening severe punishments for any person caught damaging a snowman: "The noble men from the city of Brussels proclaim that nobody, during day or night, could break any personage into pieces." City magistrates could police the snowmen-jackers, but the snowman-makers could still choose subjects of their own free will and exercise free speech. The public didn't always welcome this freedom of speech. Derogatory and miscon-strued snowmen were such a problem that restrictions had to be placed on snowman-making at the request of the public. Snow-men appeared from all walks of life, whether they mocked the working class or a member of the clergy.

Absurd texts demonizing kings, queens, and dukes by depict-ing them as made of ice and snow began to pop up in the fourteenth century. Finding mention of *anything* about snowman-making before the Little Ice Age, which proceeded a long stretch of warm weather, becomes increasingly difficult. Aside from the lack of snow, it wasn't until 1450 that newsletters began circu-lating in Europe, and with books only block-printed (starting in 1423), most of the population was still illiterate. Instead, historians must rely on chronicle writers who covered important events—like one writer who reported an extraordinary snow scene made in Doornik, Belgium, in 1422, of a lion in the role of a shepherd, watching over several sheep.

The earliest substantiated documentation of a snowman would be found in the diary of Bartolomeo del Corazza. In the winter of 1408, del Corazza described an unforgettable snow

figure just "two braccia in height" (two arms' length). It was made anonymously after four days of snow, a beautiful snow sculpture of Hercules in the middle of Piacca San Michele Berteldi in Florence—incidentally the same city of Michelangelo's legendary snowman only some eighty-six years earlier.

But that Hercules snowman in Florence has long melted. The oldest surviving snowman is in Cockaigne. Everyone living in the Middle Ages had heard of Cockaigne at one time or another. Initially, it was a real place. It wasn't until much later that it became clear that nobody knew how to get there. Like Santa Claus and the Easter Bunny, people stopped believing in the place, yet stories about it continued to circulate throughout Europe for centuries. In a letter he wrote from Hispaniola in 1498, Christopher Columbus described this place as what he was searching for years earlier, not America but Cockaigne, an idyllic land devoid of any of the world's problems. Over the years, Columbus became more determined to find this earthly nirvana, and on his third voyage he discovered the Orinoco River, which he called one of the four rivers of paradise.

Spread by legend, art, and oral history, this imaginary land became the number one tourist destination. Medieval explorers all went in search of this paradise—everyone wanted to spend time in this Spring Break of the Middle Ages. This gratuitous paradise quelled the anxieties of an uncertain afterlife. To most, heaven was going to be a tough nut to crack, and many stopped banking on it after carrying on pretty disgracefully down on earth, so best to create a plan B. Cockaigne is mentioned in the Holy Koran. Professor Herman Pleij of the University of Amsterdam believes the rooster guarding the Islamic heaven is the origin of the word *cockaigne* (pronounced like cocaine, but with a short o, as in cob). It has no connection to the drug, but it is a remarkable coincidence. Europe's food shortage forced people to eat hallucinatory mushrooms, grasses, and poppies, which in turn led to masses getting stoned and dreaming of this fantasy

land. The French version of the word, *cocaigne*, translates to "land of plenty," ultimately derived from the word "cake." Cockaigne provided hope and an imaginary escape from an unspeakable diet.

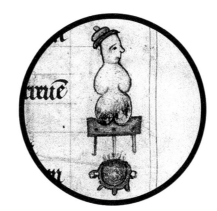

On the Cockaigne menu appeared delectable meats such as hares, deer, and wild boar, all of which let themselves be caught. Grilled fish leapt out of rivers of wine onto your plate. Roast geese waddled down streets paved in pastry, just begging to be eaten. Flying pigs and buttered birds fell from the sky like rain, directly into people's mouths. People lived in edible houses with pancake roofs and walls made of sausages.

In Cockaigne, owls laid fur coats, and horses were born with saddles. Work was forbidden. Everywhere there was convenience. Your body could be altered to your specifications and whim. All much like today's twenty-four-hour fast food, all-you-can-eat buffets, climate-controlled homes, and plastic surgery. Cockaigne, like snowmen used to mock and caricature, deployed humor founded in clashing opposites. This went beyond humor; it was a method of communicating the most sacred thoughts. Everything was turned upside down. Real churches and cathedrals show this jolting juxtaposition of holiness with shameful unholiness, with stone gargoyles and wooden deformed freaks decorating choir stalls with depictions of grotesque scenes. In a monastery in Toulouse, the sculpted tops of columns are embellished with Christ. Next to him, figures are wrestling, throwing dice, and high jumping. The stranger the contrast, the more powerful the message.

It's in the topsy-turvy world of Cockaigne that we find the first snowman ever in art of any form. Painted in the margins of

a beautiful illuminated manuscript, guarded in the Royal Library in the Hague, is a melting snowman wearing only a strange hat and a look of concern while his butt burns from a log fire under his stool. This illustration is dated around 1380. The text on the page is a sober, mournful psalm detailing the crucifixion of Jesus Christ: "Lord, you gave up the ghost shortly after uttering the words, 'It is finished.'" Next to this line is the snowman, with his back to us. The snowman is not so much an analogy for death as he is an extreme example of using humor to deal with pain. The hat tells us this is a Jewish snowman. Artists painted unusual hats on Jews to brand them as outcasts. Fools and court jesters wore hats, while Christians removed their hats in front of the altar. While Cain is depicted in dozens of paintings in a variety of hat designs, the intention behind the hat is to label the murderer Cain a Jew, while the hatless Abel is usually haloed. Paintings of the Crucifixion often show those turning away from Christ and persecutors wearing bizarre hats, including the sponge bearer (commonly known as Stephaton), who spitefully offered Jesus vinegar, and Longinus, who lanced and pierced Christ's side and supposedly converted when a drop of Jesus' blood cured his blindness.

In the fourteenth century, dying Europeans needing to know why they were afflicted by the plague sought out a scapegoat. Common people started a rumor that the Jews of northern Spain and southern France were poisoning Christian wells and spreading the plague. Pope Clement VI and recognized leaders tried to discredit the charge, calling the accusation "unthinkable," but by 1348, Jews were blamed for the disease's spread.

It is unfortunate that the oldest visual evidence of a snowman uses the cockeyed Cockaigne rationale and is anti-Semitic. For the snowman to so spectacularly and audaciously insult two religions at the same time is not easy. But such is the bizarre, unimaginable beginning of the snowman, what we today consider the safe nondenominational choice for the holidays. Today's snowman has come a long way.

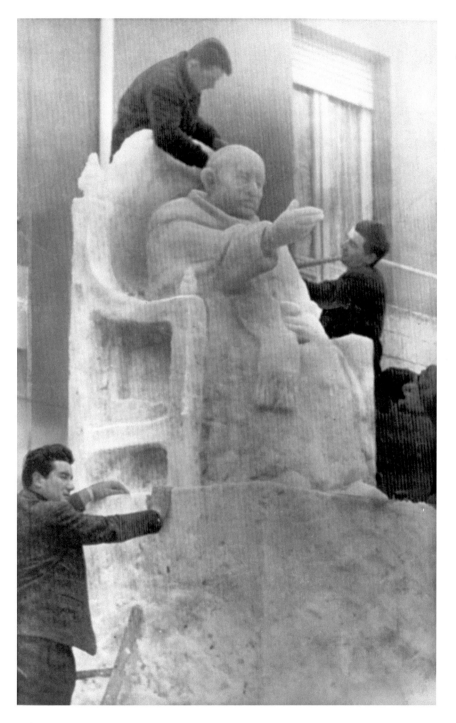

*Pope John
XXIII made
in Cesena,
Italy, 1963.*
AP
WIREPHOTO

# CHAPTER FIFTEEN

## THE ICE AGE

*Who Came First, the Caveman or the Snowman?*

ILLUSTRATION BY BOB ECKSTEIN, © 2018

The oldest reference to snowman-making in history would be the religious writings of the *I Ching* (the oldest of the Chinese texts) and the *Fengdao kejie* (seventh century), which provide their followers with guidelines for conduct and rules of worship—including how holy images may be reproduced: "Printed on paper . . . carved in ivory . . . *shaped in piled-up snow . . .* " (c. ad 610–640)

T. H. Barrett, professor of East Asian History at the University of London and a leading authority on the subject of fifth century Buddhism, explains: "Both *I Ching* and the Taoist writer of the *Fengdao kejie* want us to know that it is okay to build holy images out of snow. Maybe not everyone rushed out and did, but I would guess that at least some people did. I would therefore conclude that Taoists really did make images (sculptures) out of snow in the seventh century, and that after *I Ching*'s return to China Buddhists probably did so as well as a matter of competition."

So that brings us to the last question: Who made the first snowman? Did cavemen? With no forensic evidence to work with—no coal that may or may not have been an eye for a prehistoric snowman, no fossilized top hat or petrified carrot—it seems an impossible task. But one carrot does not a snowman make, and absence of presence isn't presence of absence. Some of the world's leading experts in anthropology affirmed that early man probably created snowmen. Snow would have been one of man's first available, pliable materials, as paleoanthropologist Prof. Emeritus Dale Guthrie of the University of Alaska points out: "Snow images probably started early in prehistory as they are so easy to produce." Indeed, of the thousands of day-to-day activities in our lives, making snowmen may very well be among the handful we still share with our ancestors.

Noted art theorist Matt Gatton states, "Once the art idea was unleashed—which may have occurred in different ways, in different places, at different times, to different peoples—it is probable that representations were made in a multitude of available materials including durable materials like stone and bone, but also impermanent materials such as wood, leather, bark, and yes, snow."

Primal art has reached us under highly distorted circumstances and is completely unrepresentative of what originally existed. Artwork made of stone with extreme conditions of preservation (the frozen, the arid, or the protected) is only the tip of the iceberg, and yet the amount of prehistoric art that has survived is in the tens of millions. Prehistoric man was an experimental being and wildly prolific during what was called the Creative Explosion, in the Upper Paleolithic period (c. 40,000–10,000 years ago), which coincided with the Ice Age. Art made in wood, feathers, hides, mud, sand, and, of course, snow was up against impossible odds of ever surviving 5,000-plus years. Any art that has survived has done so purely by chance. Destruction by animals, erosion, farming, pollution, vandalism, and even flaking

ILLUSTRATION
BY BOB
ECKSTEIN,
© 2018

means any art we see today had to be very lucky. The snowman was not so lucky.

It's assumed that primitive snowmen would have served some kind of utilitarian purpose, whether they were worshipped as snow gods or used as scarecrows to ward off undomesticated animals. Perhaps they were part of some reproductive ritual or a visual aid to teach cave tots biology. Maybe prehistoric snowmen were utilized as a sort of tombstone made in the likeness of the unfortunate soul buried below, or perhaps the dead were placed inside the snowmen (possibly the first cryogenic suspension), like the Egyptians with mummies. Many of the ancient clay anthropomorphic figurines that have survived were made using what archaeologists call "the snowman technique"—stacking rounded forms on top of each other, in what bears a striking resemblance to snowmen.

Throughout history, artists' renderings of ourselves are seldom realistic and almost always idealistic. Whether it's Michelangelo's

impossibly perfect David or the Venus of Willendorf, man has, without fail, accentuated what attributes were sought after at that time. The 25,000-year-old Venus of Willendorf, at first glance, could be mistaken for a stone snowman. But her features of extra winter weight and in-your-face fertility were attractive assets at that time in history, making Venus a top model in her day and putting her in sharp contrast to today's top models, who show no evidence of knowing how to find food. Ironically, it's exactly the former body type that matches the snowman's body shape—round. In other words, the snowman fits the Paleolithic man's perception of what is sexy and desirable.

Scientists are recognizing our species as an art-making animal, meaning we complete actions not immediately related to reproductive fitness. This includes playing. Much of Paleolithic art was executed quickly, in a playful manner. New forensic technology used on fossil handprints is now telling us that all ages and both sexes created art, and that Paleolithic children made art. This is evidence of the role of play in the development of art. In other words, prehistoric snowmen could have existed solely because they were fun to make. Or they were nice yard decorations. The idea that children created prehistoric art is exciting and builds a case for the early snowman. Because of the way our brains develop, children have always been more likely to build snowmen, as they are more likely to imagine familiar images within other materials. Knowing that, coupled with the fact that most of the

population was under twenty years old (forty was unimaginably old back then), transforming nature into culture seems quite natural. Playfulness plays an important function in civilization. It was young adults playing in their garage who stumbled on the most significant invention of our lifetime, the computer. Everything's connected.

The connection between the caveman and the snowman is extremely plausible. Man has always had two primal instincts, enjoyed since the dawn of time: 1) to create a likeness of himself, and 2) the propensity for putting one thing on top of another.

Why wouldn't we believe snowmen were made—where's the evidence to the contrary? If man could build Stonehenge and the Great Pyramids, then building a snowman should have been child's play.

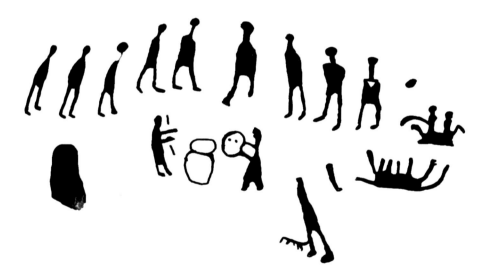

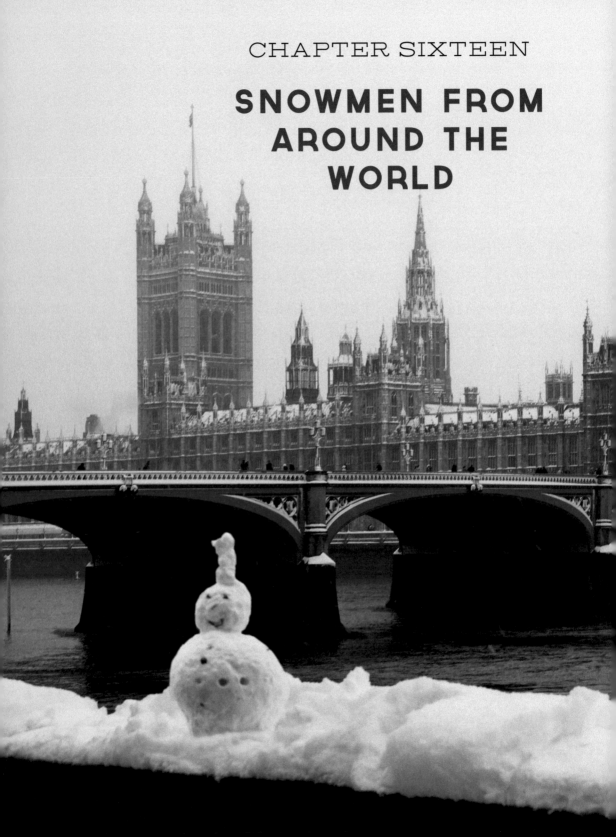

# SNOWMEN FROM AROUND THE WORLD

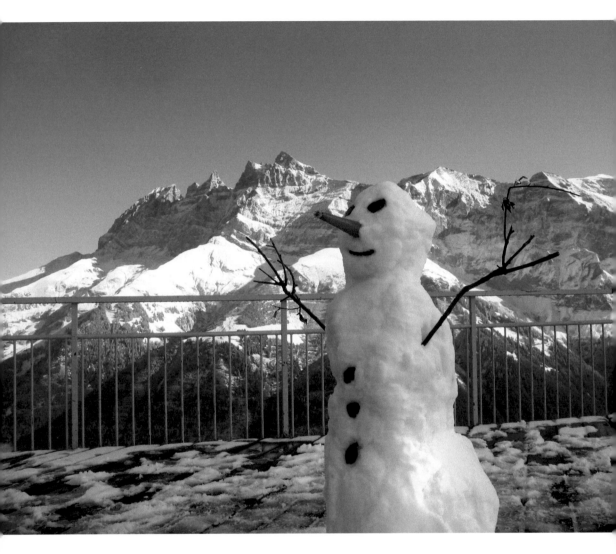

*A snowman on top of the Plein Ciel Hotel in the Swiss Alps.*
PHOTOGRAPH BY JEAN-PHILIPPE LAROCHE

**PREVIOUS SPREAD:** *London had the heaviest snowfall in eighteen years in February 2009. The city had no bus service and schools closed. Instead people spent their day making snowmen.*
PHOTOGRAPH BY ERIC FLAMANT, DREAMSTIME.COM

There are now companies that will ship snow anywhere, so that you can build a snowman (one company is called Snowman in a Box). One snowman survived an 8,552 km (5,314 mile) journey from Japan to the desert of Bahrain without any refrigeration thanks to revolutionary insulation by Panasonic. It was a publicity stunt inspired by a Bahraini girl on Facebook named Amna al-Haddad who wanted her younger brother Saleh to see snow for the first time. The 102 kg (225 lb) box of snow was shipped with a sticker on the outside that read: "Snowman Inside."

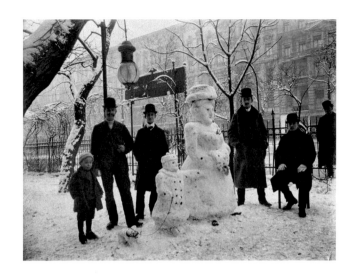

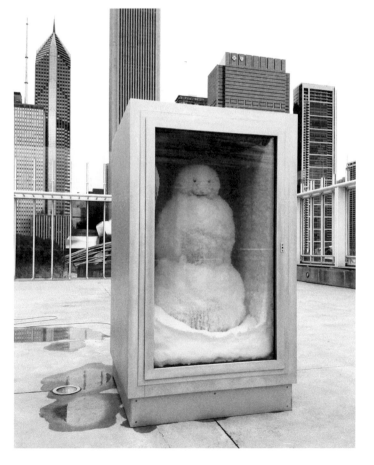

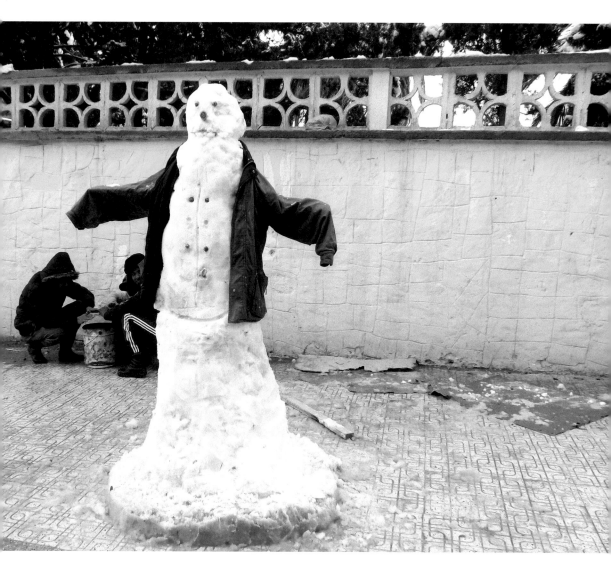

**ABOVE:** *Aïn Séfra, Algeria. In 2017 the Sahara Desert recorded the biggest snowfall in living memory after a freak winter storm in Algeria.*
PHOTOGRAPH BY KARIM BOUCHETATA. COURTESY OF GEOFF ROBINSON PHOTOGRAPHY

**OPPOSITE TOP:** *The Netherlands. The Dutch Queen Wilhelmina and Princess Juliana as snow-women, January 21, 1913.* SPAARNESTAD PHOTO

**OPPOSITE BOTTOM:** *Chicago. Snowman Installation by Peter Fischli and David Weiss, 2017. On the roof of the Art Institute of Chicago.*
PHOTOGRAPH BY BOB ECKSTEIN

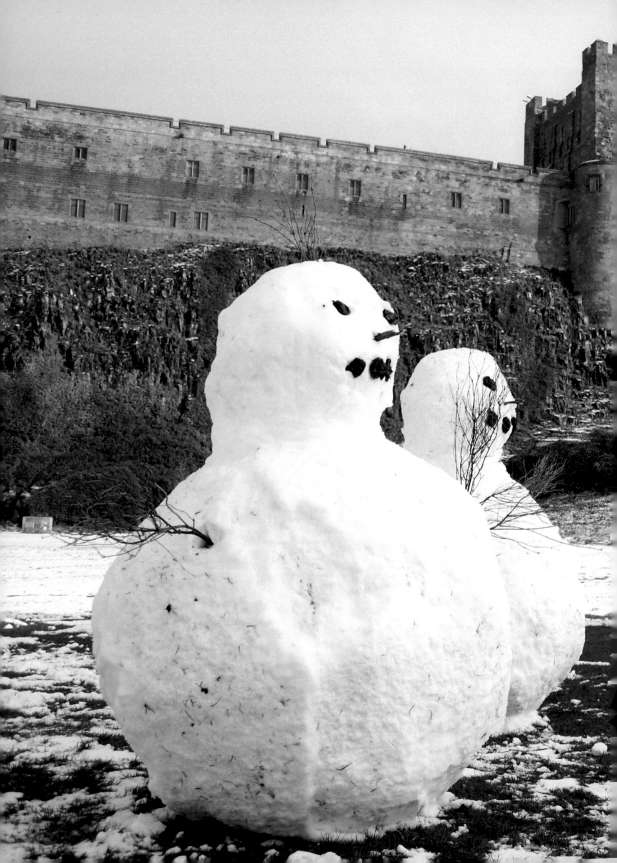

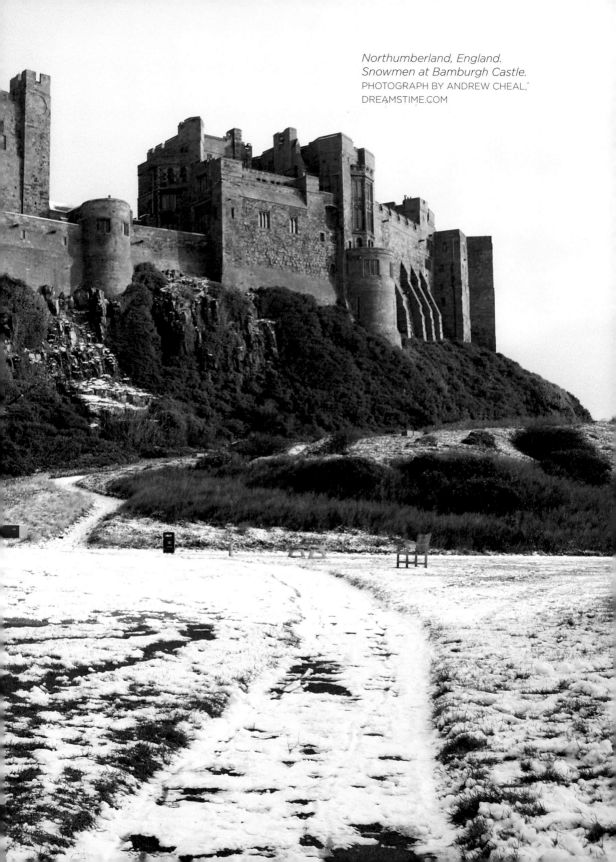

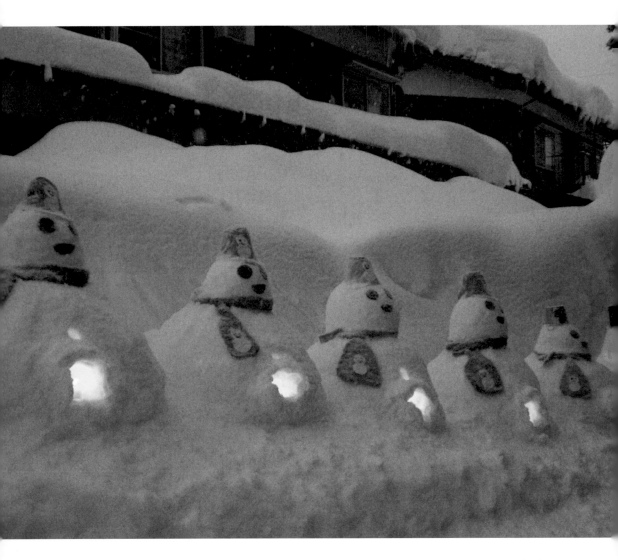

*Ishikawa Prefecture, Japan. The Shiramine Yukidaruma Matsuri Festival in 2012. At dusk candles were lit in the bellies of all the snowmen. Yukidarumas (or snow darumas) were inspired by the good luck toy, the Dharma, which, like snowmen, have no legs and, like Japanese snowmen, are made with only two balls stacked on top of each other. The Dharma toy has earned a prominent place in Japan's cultural heritage and typifies his elevated position: No matter how you push the toy, it bounces back into the upright position, like a weeble. The Dharma comes from Bodhidharma, a sixth-century Indian Buddhist who founded Zen Buddhism. According to legend, Bodhidharma sat immobile, meditating for nine straight years, resulting in such severe pins and needles that he lost the use of his arms and legs. It was said he went on to spread his teachings, rolling himself all the way from India to Japan.* PHOTOGRAPH COURTESY OF MARLIES HOLVOET

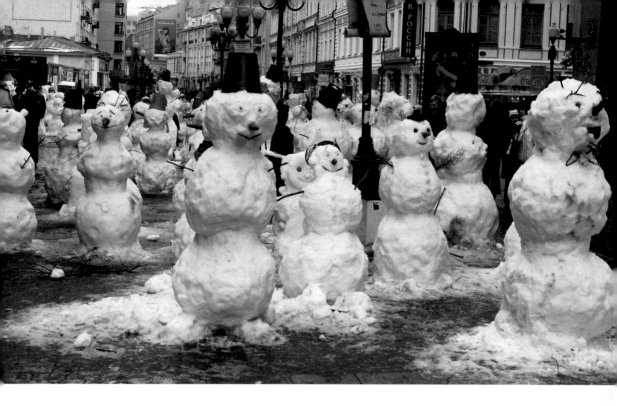

*Moscow, 2005. At the premiere of world famous clown Vyacheslav Polunin's Snow Show, ticket holders were greeted by snowmen created by the Academy of Fools. (Part of the final exam for students of the Academy is to make a snowman.)*
PHOTOGRAPH BY NIHOLAS DANILOV, MOSNEWS.COM

*New York City. From the top of Manhattan in Fort Tryon Park. What is the snowman's biggest threat–climate change, or everyone taking off their gloves to be on their cell phones?*
SNOWMAN BY ROY KUSHER.
PHOTOGRAPH BY WALLACE FLORES

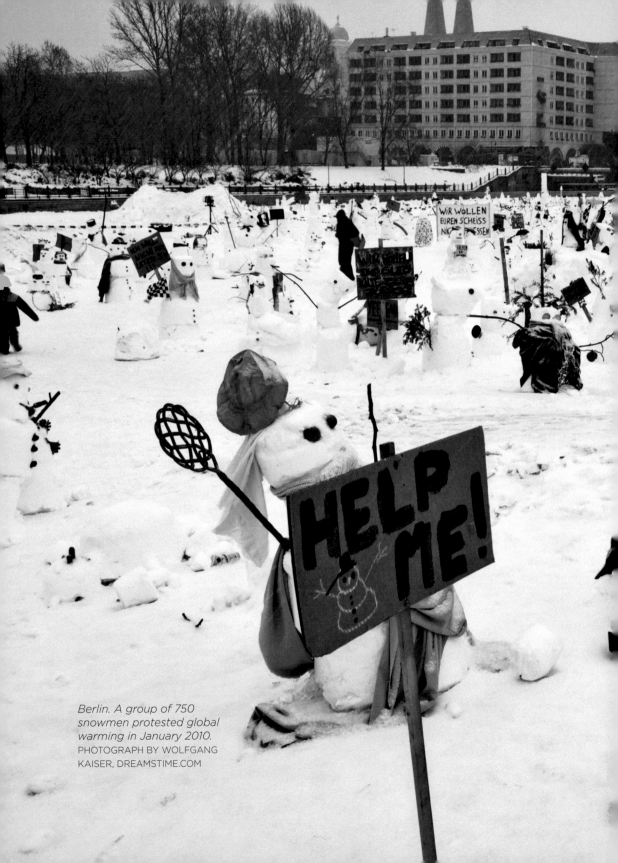

*Berlin. A group of 750 snowmen protested global warming in January 2010.*
PHOTOGRAPH BY WOLFGANG KAISER, DREAMSTIME.COM

*Wrightsville Beach, North Carolina.*
PHOTOGRAPH BY DIANE FRIEDMAN

**FACING PAGE:** *Fort Tryon Park, New York City.*
PHOTO BY ROY KUSHER

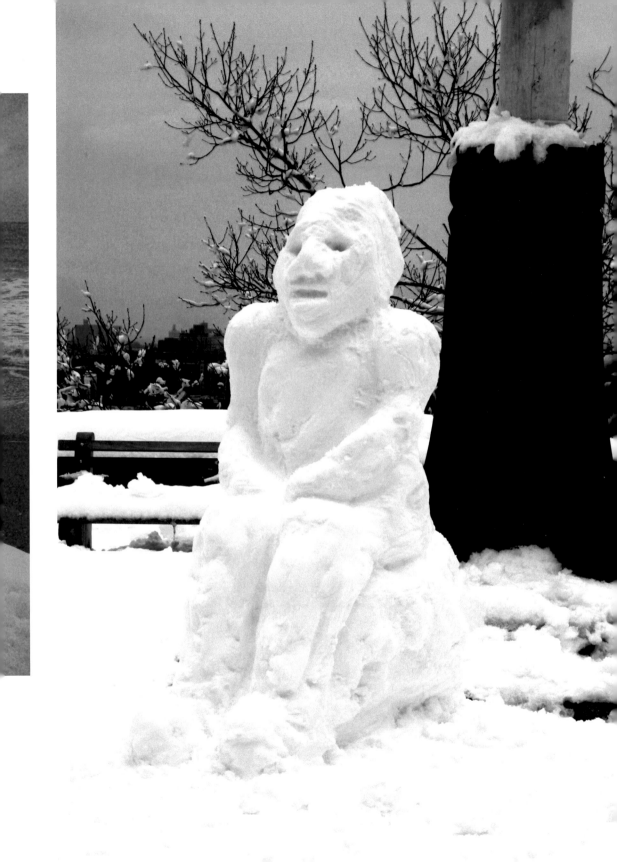

In Snowman Valley Park in Harbin, China, a total of 2,018 snowmen were built on January 8, 2018. This fellow, named Haxiaoxue (meaning "Harbin Little Snow"), was the tallest at twenty meters.

# FROST BITES

Snowman-making was banned in 1996 by the Taliban, which outlawed all nonreligious art and music, prohibiting children's activities such as kite flying, playing with dolls, and building snowpersons.

Golf hackers hate the word snowman because it means an eight, a disastrous triple bogey at best, depending what par is.

For thousands of years, Eskimos have made a wide range of anthropomorphic figures, but they generally did so using stone, to create direction pointers and messages for the next group coming along, and rarely sculpted in snow. Today, hunters sometimes carve snow animals as practice targets, and for Eskimo children to pretend to stalk and attack.

Frosty was drawn in Japan based on initial drawings made by *MAD* magazine cartoonist Paul Coker, Jr. The producers wanted to emulate Coker's greeting card look, which he made famous at Hallmark. It was the last film for Frosty's narrator, Jimmy Durante.

*The Collection of the Designs of the Colossal Snow Figures, Faces, and Groups* is a book of prints that documents a fundraiser in January 1772 by the Antwerp Academy of Belgium, whereby two dozen masterful snow sculptures were constructed in the streets and squares of Antwerp. The figures were about ten to twenty feet in height and were based on classical figures: Hercules, Neptune, and the largest at forty feet, Bacchus.

Psychologists say that seeing a snowman in your dreams suggests that you are emotionally cold or have perhaps behaved insensitively and cold-heartedly.

A total of 12,379 snowmen were made in Sapporo, Japan, in 2003 during a snow festival in efforts to breaking the world's record for most snowmen and outnumbering the number of humans in the town. Twelve years later, over 1,400 residents of Akabira, Japan, built 2,036 snowmen in one hour to break a Guinness World Record set twelve days earlier in Iiyama, Japan (1,585 by 600-plus people). Then in February 2018, 1,678 Michigan Technological University students made 2,228 snowmen in one hour, which is unofficially the one hour world's record, awaiting Guinness's decision.

# BIBLIOGRAPHY

Addams, Charles. *The World of Charles Addams*. New York: Alfred A. Knopf, 1991.

Alperson, Philip. *The Philosophy of the Visual Arts*. New York: Oxford University Press, 1992.

Amendola, Joseph. *Ice Carving Made Easy*. New York: Van Nostrand Reinhold, 1994.

Anderes, Fred, and Ann Agranoff. *Ice Palaces*. New York: Abbeville Press/Cross River Press, 1983.

Andersen, Jens. *Hans Christian Andersen: A New Life*. New York: Overlook Press, 2005.

*Arctic Miscellanies: A Souvenir of the Late Polar Search by the Officers and Seamen of the Expedition*. London: Colburn, 1852.

Avery, Charles. *Florentine Renaissance Sculpture*. London: J. Murray, 1970.

Bakish, David. *Jimmy Durante: His Show Business Career, with an Annotated Filmography and Discography*. Jefferson, NC: McFarland, 1995.

Bahn, Paul G. *The Cambridge Illustrated History of Prehistoric Art*. Cambridge, UK: Cambridge University Press, 1998.

Barrett, T. H. "The Feng-tao k'o and Printing on Paper in Seventh-Century China." *Bulletin of the School of Oriental and African Studies* 60, no. 3 (October 1997): 538–40.

Bettley, James. *The Art of the Book: From Medieval Manuscript to Graphic Novel*. London: V & A Publications, 2001.

Birch, John. *The Story of the Schenectady Massacre*. Schenectady, NY: Schenectady County Historical Society, 1977.

Blankert, Albert (w. Doortje Hensbroek-van der Poel, George Keyes, Rudolph Krudop and Willem van de Watering). *Frozen Silence*. Amsterdam: Waterman Gallery, 1982.

Boyarsky, P. V., and J. H. G. Gawronski. *Northbound with Barents: Russian-Dutch Archaeological Research on the Archipelago Novaya Zemlya*. Amsterdam: Uitgeverij jan Mets, 1995.

*The Boy's Book of Sports: Or Exercises and Pastimes of Youth*. New Haven: Babcock, 1838.

Bradshaw, David, and Kevin J. H. Dettmar, eds. *A Companion to Modernist Literature and Culture*. Malden, MA: Wiley-Blackwell, 2006.

Brock, H. I. "American Life Pictorial in the Prints of Currier & Ives." *New York Times*, December 29, 1929.

Burke, James. *Connections*. Boston: Little, Brown and Company, 1978.

Cabot, Mary R., ed. *Annals of Brattleboro, 1681–1895*. Brattleboro, VT: E. L. Hildreth & Co., 1922.

Cantor, Norman. *In the Wake of the Plague: The Black Death and the World It Made*. New York: Simon & Schuster, 2001.

Carpenter, G. W. *An Account of the Burning of Schenectady*. New York Public Library manuscript records, 1834.

Catoir, Barbara. *Miro on Mallorca*. Munich: Prestel, 1995.

Clausen, Søren, and Stig Thøgersen. *The Making of a Chinese City: History and Historiography in Harbin*. New York: Routledge, 1995.

Clayson, Hollis. *Paris in Despair: Art and Everyday Life Under Siege*. University of Chicago Press, 2005.

Champlin, John Denison. *Young Folks' Cyclopædia of Common Things*. New York: Holt and Co., 1879.

Cobb, James. *Journal of American Folklore* 105, no. 415 (Winter 1992): 19.

———. "'Somebody Done Nailed Us on the Cross': Federal Farm and Welfare Policy and the Civil Rights Movement in the Mississippi Delta." *Journal of American History* 77, no. 3 (December 1990): 912–936.

Conde, Edwin G. *The Most Beautiful Land* (manuscript story), ca. 1935.

Conroy, Patricia, and Sven Rossel. *The Diaries of Hans Christian Andersen*. Seattle: University of Washington Press, 1990.

Cusack, Tricia. BBC *Radio 4*. England: University of Birmingham, 2001.

Dailey, Rev. W. N. P. *The Burning of Schenectady*. Schenectady, NY: Documentary Records and Historical Notes, D. D., 1940.

Dales, Frederick. *A Story of Schenectady and the Mohawk Valley*. Schenectady, NY: Maqua Co., 1929.

Dawson, W. F. *Christmas: Its Origin and Associations*. London: Elliot Stock, 1902.

De Meeüs, Adrien. *History of the Belgians*. New York: Frederick Praeger, 1962.

Dissanayake, Ellen. *Homo Aestheticus: Where Art Comes From and Why*. New York: Free Press, 1992.

Dotz, Warren. *Meet Mr. Product: The Art of the Advertising Character*. San Francisco: Chronicle Books, 2003.

Fagan, Brian. *The Little Ice Age: How Climate Made History*. New York: Basic Books, 2000.

Felton, Bruce, and Mark Fowler. *Felton & Fowler's Best, Worst, and Most Unusual*. New York: Crowell, 1975.

Floore, Pieter M. *The Dutch Exploration of the North-Eastern Passage and Western Contacts with the Indigenous Population of the Arctic*. Amsterdam, Netherlands.

*A Florentine Diary From 1450 to 1516 by Luca Landucci Continued by an Anonymous Writer Till 1542*. New York: E.P. Dutton & Company, 1927.

Goldsworthy, Andy. *Midsummer Snowballs*. New York: Harry Abrams Publishers, 2001.

Goode, Ruth. *People of the Ice Age*. New York: Macmillan Publishing, 1973.

Guthrie, R. Dale. *The Nature of Paleolithic Art*. The University of Chicago Press, 2005.

Hajdú, Péter. *The Samoyed Peoples and Languages*. The Hague, Netherlands: Indiana University Publications, 1963.

Halt, Edwin Jr. *The Eskimo Storyteller*. Knoxville: The University of
   Tennessee Press, 1975.

Hart, Larry. *Tales of Old Schenectady*. Chap. 8, pp. 37–40. Scotia,
   NY: Old Dorp Books, 1875.

Herlihy, David. *The Black Death and the Transformation of the
   West*. Cambridge, MA: Harvard University Press Cambridge,
   1997.

Hone, William. *The Everyday Book and Table Book*. Pub. by
   Assignment, 1830.

Housman, Laurence. *The Snowman, A Morality in One Act*. New
   York: S. French, 1916.

Howells, William Dean. *Novels—Selections*. New York: Viking
   Press, 1982.

Jackson, Frederick George. *The Great Frozen Land (Bolshaia
   Zemelskija Tunndra): Narrative of a Winter Journey across the
   Tundras and a Sojourn among the Samoyads*. London, New
   York: Macmillan and Co., 1895.

Janello, Amy, and Brennon Jones. *The American Magazine*. New
   York: Harry Abrams, 1991.

Jones, Malcolm. *The Secret Middle Ages: Discovering the Real
   Medieval World*. Westport, CT: Praeger Publishers, 2002.

Joseph, Joan. *Folk Toys around the World and How to Make
   Them*. New York: Parents Magazine Press, 1972.

Kael, Pauline. *Raising Kane*. New York: Bantam Books, 1971.

Kern, Louis. *An Ordered Love: Sex Roles and Sexuality in
   Victorian Utopias—The Shakers, the Mormons & the Oneida
   Community*. Chapel Hill: University of North Carolina Press,
   1981.

Kirk, Ruth. *Snow*. Seattle: University of Washington Press, 1998.

Klepper, Robert K. *Silent Films, 1877–1996: A Critical Guide to 646
   Movies*. London: McFarland & Co. Inc., 1999.

Knox, Charles B. *The Old Mohawk-Turnpike Book*. Gelatine Co. Inc.

Kohn, Livia. *The Daoist Monastic Manual: A Translation of the
   Fengdao Kejie*. New York: Oxford University Press, 2004.

Lederer, Wolfgang. *The Kiss of the Snow Queen: Hans Christian Andersen and Man's Redemption by Woman*. Berkeley: University of California Press, 1986.

Leroi-Gourhan, André. *Treasures of Prehistoric Art*. Translated by. Norbert Guterman. New York: Harry N. Abrams, 1967.

Levarie, Norma. *The Art & History of Books*. New Castle, DE: Oak Knoll Press, 1995.

Little, Stephen. *Taoism and the Arts of China*. Art Institute of Chicago, University of California Press, 2000.

MacArthur, Greg. *Exposure: Two Plays*. Toronto: Coach House Books, 2005.

Mellinkoff, Ruth. *Outcasts: Signs of Otherness in Northern European Art of the Late Middle Ages*. Berkeley: University of California Press, 1993.

Mergen, Bernard. *Snow in America*. London: Smithsonian Institution Press, 1997.

Meyer, Robert. *Festivals U.S.A.* New York: Ives Washburn, Inc., 1950.

Meyndertsz van den Bogaert, Harmen. *A Journey into Mohawk and Oneida Country, 1634–1635: The Journal of Harmen Meyndertsz van den Bogaert*. Syracuse, NY: Syracuse University Press, 1988.

Miller, Alec. *Tradition in Sculpture*. London: Studio Publications, 1949.

Moffett, Charles. *Impressionists in Winter*. Philip Wilson Publishers, 2003.

Moody, Dr. Joseph. *Arctic Doctor*. New York: Dodd, Mead & Company, 1955.

Morris, Marcia. *The Literature of Roguery in Seventeenth- and Eighteenth-Century Russia*. Evanston: Northwestern University Press, 2000.

Morris, Richard Joseph. *Sinners, Lovers, and Heroes: An Essay on Memorializing in Three American Cultures*. Albany: State University of New York Press, 1997.

Muchembled, Robert. *Culture populaire et culture des elites dans la France moderne*. Louisiana State University Press, 1985.

Mudge, Rev. Zachariah. *Arctic Heroes: Facts and Incidents of Arctic Explorations from the Earliest Voyages to the Discovery of the Fate of Sir John Frankl*in. New York: Nelson & Phillips, 1875.

The National Library of Wales. Mary Dillwyn's Llysdinam Album. Reference: 004455920

Neal, Avon. *Ephemeral Folk Figures: Scarecrows, Harvest Figures, and Snowmen*. New York: Clarkson N. Potter, 1969.

Nebesky-Wojkowitz, Réne von. *Where the Gods Are Mountains: Three Years among the People of the Himalayas*. London: Weidenfeld and Nicolson, 1956

Nellis, Milo. *History from America's Most Famous Valleys: The Mohawk Dutch and the Palatines*. New York: Dodd Mead & Company, 1879.

Newman, Benjamin. *Hamlet and the Snowman: Reflections on Vision and Meaning in Life and Literature*. New York: American University & Peter Lang Publishing, 2000.

Newman, Paul B. *Daily Life in the Middle Ages*. London: McFarland & Company, 2001.

Nissenbaum, Stephen. *The Battle For Christmas*. New York: Alfred A. Knopf, 1997.

Niver, Kemp R. *Early Motion Pictures: The Paper Print Collection in the Library of Congress*. Washington, D.C.: Library of Congress, 1985.

Page, P. K. *The Glass Air: Selected Poems*. Toronto: Oxford University Press, 1985.

Pearson, Professor Jonathan A. M. *A History of the Schenectady Patent in the Dutch and English Times*. Pages 244-270. Livingston, Robert. *The Schenectady Massacre*. Journal. April 14,1690. Albany: Joel Munsells Sons, Printers, 1883.

Perez-Higuera, Teresa. *Medieval Calendars*. London: Trafalgar Square, 1999.

Perkins, Bill. *The Naked Truth: Sexual Purity for Guys in the Real World*. Grand Rapids, MI: Zondervan/Youth Specialties, 2004.

Perrie, Maureen. *The Pretenders and Popular Monarchism in Early Modern Russia*. Cambridge, UK: Cambridge University Press, 1995.

Pleij, Herman. *De sneeuwpoppen van 1511: Literatuur en Stadscultuur Tussen Middeleeuwen en Moderne Tijd*. Amsterdam: Meulenhoff, 1988.

———. *Dreaming of Cockaigne: Medieval Fantasies of the Perfect Life*. New York: Columbia University Press, 1997.

Plummer, Mark A. *Lincoln's Rail-Splitter*. Urbana: University of Illinois Press, 2001.

Pottre, Jan de. Diary

Quennell, Marjorie, and C. H. B. *Everyday Life in Prehistoric Times*. New York: G. P. Putnam's Sons, 1980.

———. *A History of Everyday Things in England from 1066–1799*. London: G. P. Putnam's Sons, 1931.

Ravitch, Diane. *The Language Police: How Pressure Groups Restrict What Students Learn*. New York: Alfred A. Knopf, 2003.

Ray, Dorothy Jean. *Eskimo Art: Tradition and Innovation in North Alaska*. Seattle: Henry Art Gallery by the University of Washington Press, 1977.

Reid, W. Max. *The Mohawk Valley: Its Legends and Its History*. New York: Knickerbocker Press, 1901.

Ristinen, Elaine, trans. *The Nganasan: The Material Culture of the Tavgi Samoyeds*. Bloomington: Indiana University & The Hague: Mouton & Co., 1966.

Robb, Graham. *Strangers: Homosexual Love in the 19th Century*. London: Picador, 2003.

Roberts, George S. *Old Schenectady*. Schenectady, NY: Robson & Adee Publisher, 1904.

Roberts, Mary Newlin. "Michelangelo and The Snowman: Episode from the Life of a Young Michelangelo." *Child Life*, Benjamin Franklin Literary & Medical Society, April 2000.

Robiano, Eugen-Jean-Bapiste. *Collection des desseins des figures Colossales & des Groupes qui ont ete faits de Neige*. Aanvers, France, 1772.

Rogers, Robert. *Amazing Reader in the Labyrinth of Literature*. Chapel Hill: Duke University Press, 1982.

Rose, Barbara. "Jasper Johns: The Seasons." *Vogue*, January 1987.

Rosenblum, Naomi. *A History of Women Photographers*. New York: Abbeville Press, 1994.

Rosenkranz, Patrick. *Rebel Visions: The Underground Comix Revolution 1963–1975*. Seattle: Fantagraphics Books, 2002.

Roth, Norman. Medieval Jewish Civilization: An Encyclopedia. New York: Routledge, 2003.

Sanders, John. *Early History of Schenectady and Its First Settlers*. Albany, NY: Van Benthuysen Printing House, 1879.

Sands, George. *The Snow Man*. Boston: Roberts Brothers, 1871.

Shakespeare, William. *The History Plays*. New York: Henry Holt and Company, 1951.

Stevens, Wallace. *The Collected Poems of Wallace Stevens*. New York: Alfred A. Knopf, 1954.

Suchtelen, Ariane van. *Holland Frozen in Time: The Dutch Winter Landscape in the Golden Age*. Zwolle, Netherlands: Waanders Publishers, 2001.

Sylvester, Nathaniel Bartlett. *History of Saratoga County*. Philadelphia: Everts & Ensign, 1878.

Thomas, Dylan. "Foster the Light." *The Columbia World of Quotations*. Columbia Encyclopedia, 1996.

Veeder, Millicent. *Door to the Mohawk Valley: A History of Schenectady for Young People*. Albany: Cromwell Printery, 1947.

Veer, Gerritt de. *Diarivm navticvm*. Amsterdam, 1598.

Vrooman, John J. *The Massacre*. Johnstown, NY: The Baronet Litho Company, 1954.

Wagner, Linda. *Critical Essays on Sylvia Plath*. Boston: G. K. Hall & Company, 1984.

Welles, Orson, and Herman J. Mankiewicz. *The Shooting Script*. Boston: The Atlantic Monthly Press, 1941.

Whitburn, Joel. *Pop Memories, 1890–1954: History of American Popular Music*. Menomonee Falls, WI: Billboard Publishing, 1986.

White, Curtis. "The Spirit of Disobedience: An Invitation to Resistance." *Harper's*, April 2006.

White, Randall. *Prehistoric Art: The Symbolic Journey of Humankind*. New York: Harry N. Abrams, 2003.

Whittaker, C. E. *Arctic Eskimo*. London: Secley, Service & Co., 1937.

Willoughby, Martin. *A History of Postcards*. London: Bracken Books, 1992.

Wullschläger, Jackie. *Hans Christian Andersen: The Life of a Storyteller*. London: Allen Lane, 2000.

Zeni, David. *A Forgotten Empress*. Fredicton, New Brunswick: Goose Lane, 1998.

# ACKNOWLEDGMENTS

Thank you to my all friends and colleagues for your help. Thanks to Trevor Crafts, Roy Kusher, Wallace Flores, Trevor Wilson, Susanna Font and the Schenectady County Historical Society, Geoffrey Robinson Photography, and Rich Goldschmidt of Rankin Bass Productions for additional images; Mike Maloney, Librarian & Archivist, Schenectady County Historical Society; and special thanks to James Lafton, Ashley Swinnerton, and Arthur Wehrhahn of MoMA for all your extra effort providing one of the earliest movie stills of a snowman.

Special thanks to my friend and editor, Ursula Cary. And to Piper Wallis, Sally Rinehart, Arielle Lewis, Melissa Evarts, Jessica Kastner, Kristen Mellitt, Shana Capozza, Evan Helmlinger, and the rest of the team at Globe Pequot for all your hard work and support. You have all been wonderful to work with.

And special gratitude to my wife, Tamar Stone, and agent and friend, Joy Tutela.

*"So where do you see yourself in five months?"*

CARTOON BY BOB ECKSTEIN, © 2018.
ORIGINALLY PUBLISHED IN BARRON'S

# ABOUT THE AUTHOR

**Bob Eckstein** is an award-winning illustrator and writer, snowman expert, and *New Yorker* cartoonist. His previous book is *Footnotes from the World's Greatest Bookstores*. He lives with his wife in New York City.

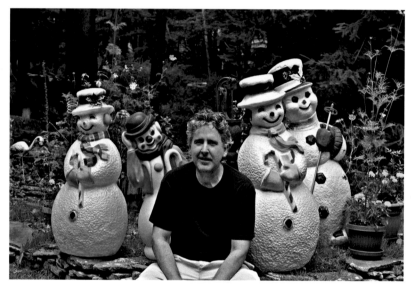

PHOTO BY CARLO SAVO, CARLOSAVO.COM

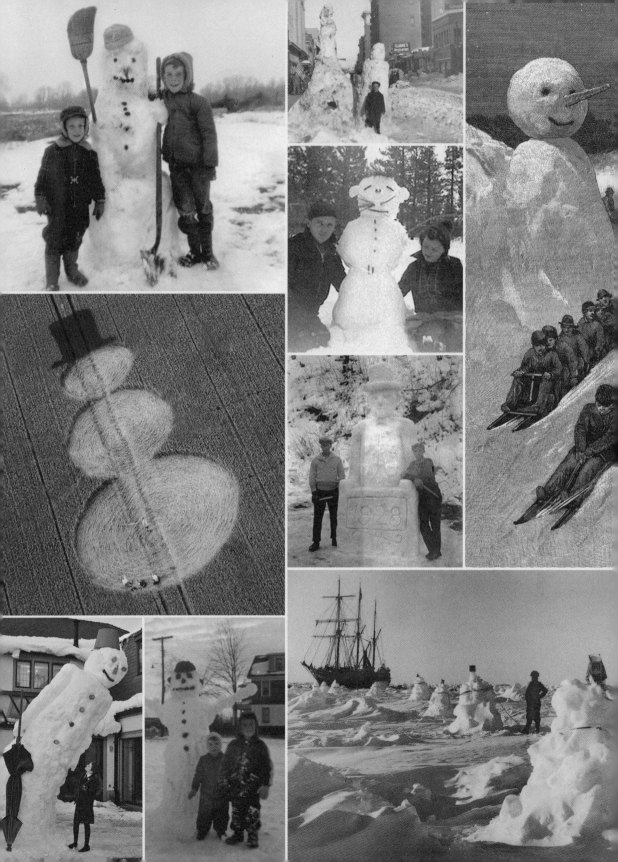